CONTENTS

SPORTS

ARCHERY7
BASEBALL I8
BASEBALL II9
BASEBALL III10
BASEBALL IV11
BODYBUILDING I12
BODYBUILDING II13
BOXING14
FISHING I15
FISHING II16
FISHING III17
FOOTBALL I18
FOOTBALL II19
FOOTBALL III20
HOCKEY21
HUNTING I22
HUNTING II23
RAQUETBALL24
SAILING25
SKIING I26
SKIING II27
SKI BUNNY28
SOCCER I29
SOCCER II30
SURFING I31
SURFING II32
SWIMMING33
SWIMMING/MERMAID34
TENNIS I35
TENNIS II36
TENNIS III37
VOLLEYBALL38
WATERSKIING I39
WATERSKIING II40
WATERSKIING III41
WATERSKIING IV42
WRESTLING43

HOBBIES

ARTIST47
AEROBICS48
BEACH/SUNTANNING49
BOATS50
DANCING/PARTYING51
DANCING52
DRINKING I53
DRINKING II54
DRIVING I55
DRIVING II56
DRIVING III57
GAMBLING I58
GAMBLING II59
HORSEBACK RIDING I60
HORSEBACK RIDING II61
KNITTING62
PETS/WALKING DOG I63
PETS/WALKING DOG II64
PIANO65
READING66
SAILING67
SINGING68
TRUMPET69
SHOPPING I70
SHOPPING II71
SEWING72

CONTENTS

PROFESSIONS

BOSS 75
BUSINESSMAN/SALES 76
CARPENTER 77
COMPUTER 78
DENTAL HYGIENE 79
DOCTOR 80
GUITAR 81
HAIRDRESSER 82
LAWYER 83
MAKING MONEY 84
MILITARY/HELICOPTER 85

MILITARY/NAVY 86
MILITARY/PARACHUTE 87
MILITARY/TANK 88
MILITARY/RAMBO 89
NURSE 90
REAL ESTATE 91
SALESMAN 92
SECRETARY 93
SINGING 94
SURGEON 95

KIDS ONLY

BABIES/BOTTLE 99
BABIES/CRAWLING 100
BABIES/SWIMMING 101
BALLET 102
BICYCLE 103
CHASING BOYS 104
DEVIL 105
GYMNASTICS 106
NINTENDO 107

PETS I 108
PETS II 109
ROLLERSKATING 110
SKATEBOARDING I 111
SKATEBOARDING II 112
TRICYCLE 113
TROUBLE 114
VIDEO ARCADE 115

INTRODUCTION

Coming up with gag ideas on the spot can be a nerve-wracking experience. That is why this book was created ~ to aid you with ideas so that you do not have to go through that kind of ordeal.

There is, literally, an infinite amount of gag jokes you can use. What I have compiled here are 100 or so drawing that you, the caricaturist, can refer to and use as a beginning arsenal. Mix and match bodies, signs, thought bubbles to your own liking. Use this book as a springboard for your own ideas. Copy the drawings and memorize them. Pretty soon you will get the idea on how to put any gag together, even the most obscure profession. Remember, practicing over and over makes the process go faster and easier. Draw as many objects you can from memory and life. Keep a file of cartoons that seem to solve drawing problems of difficult objects. It's also a good idea to maintain a file of photographs of various objects for referral.

I wish you much luck and fortune in your caricaturing endeavors.
Happy drawing!

Sincerely,

Jim van der Keyl

SPORTS

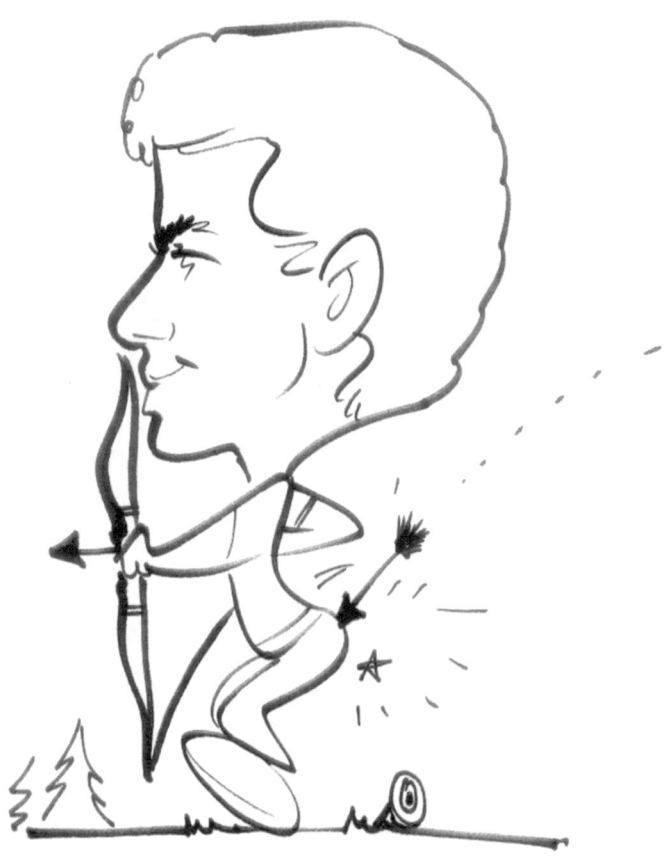

ARCHERY

SPORTS

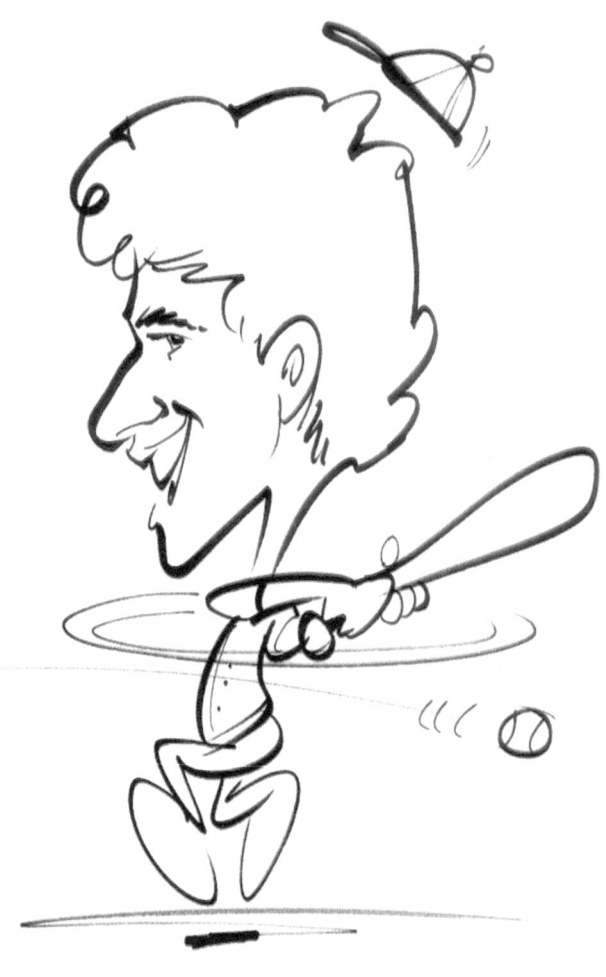

BASEBALL 1

SPORTS

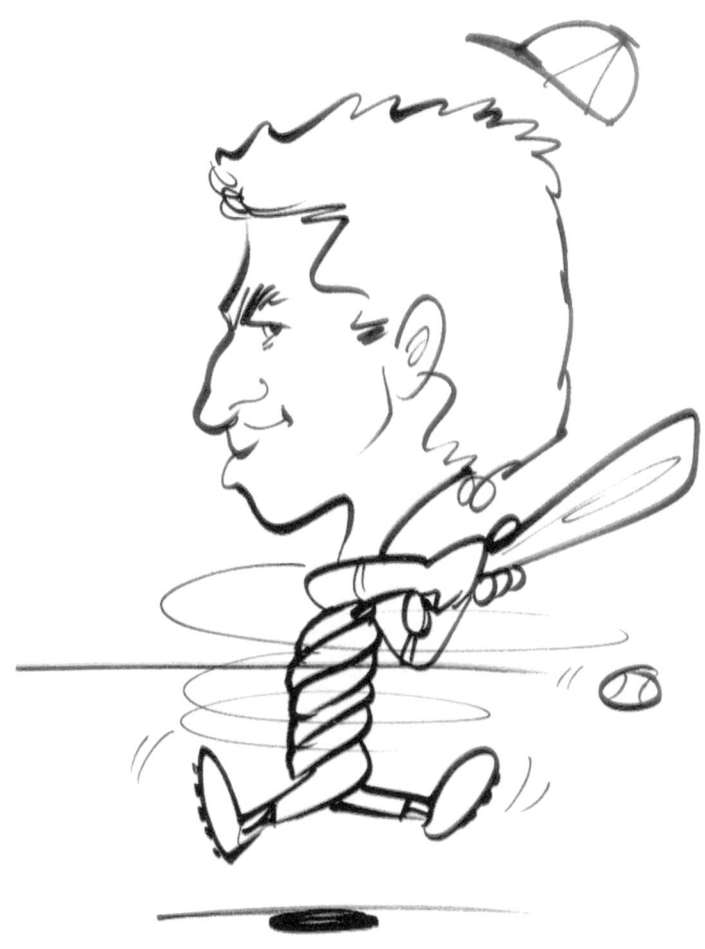

BASEBALL II

SPORTS

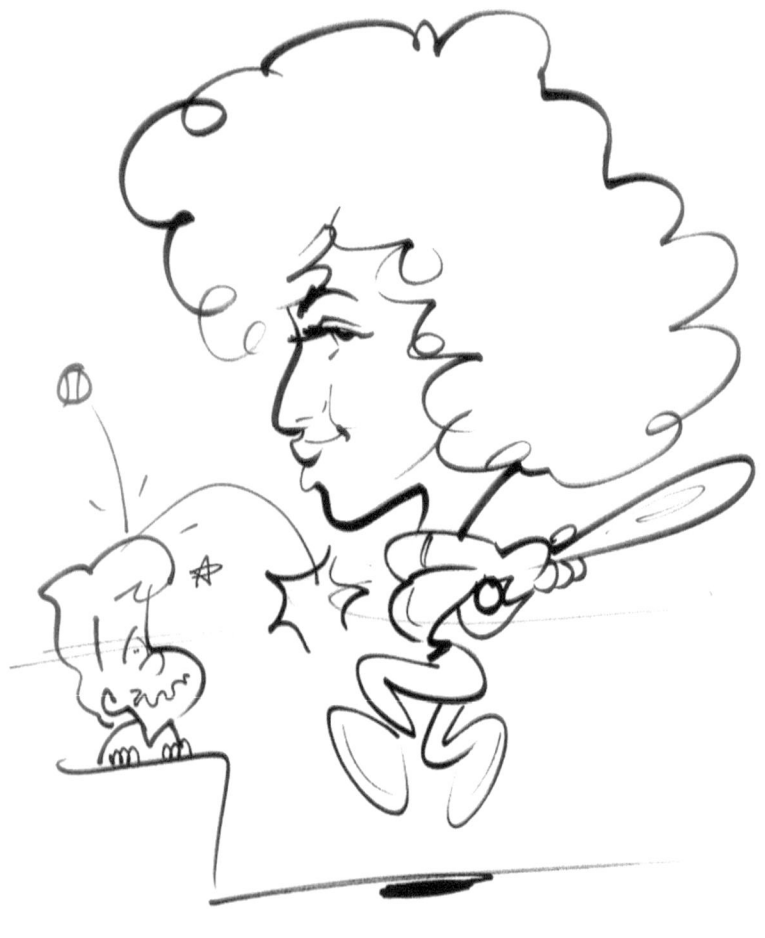

BASEBALL III

SPORTS

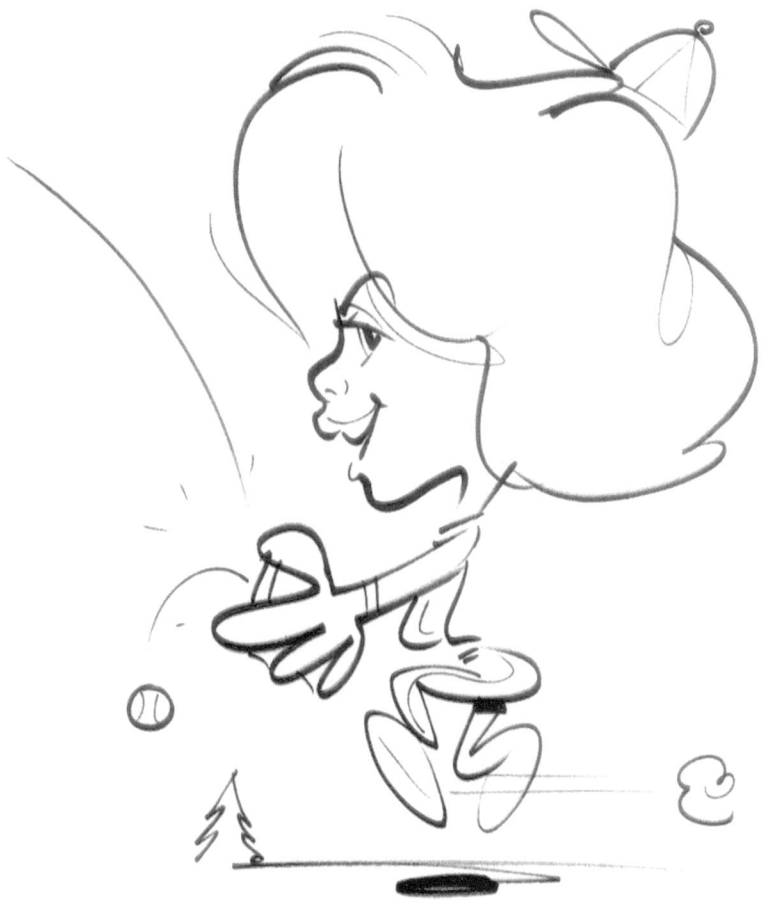

BASEBALL IV

SPORTS

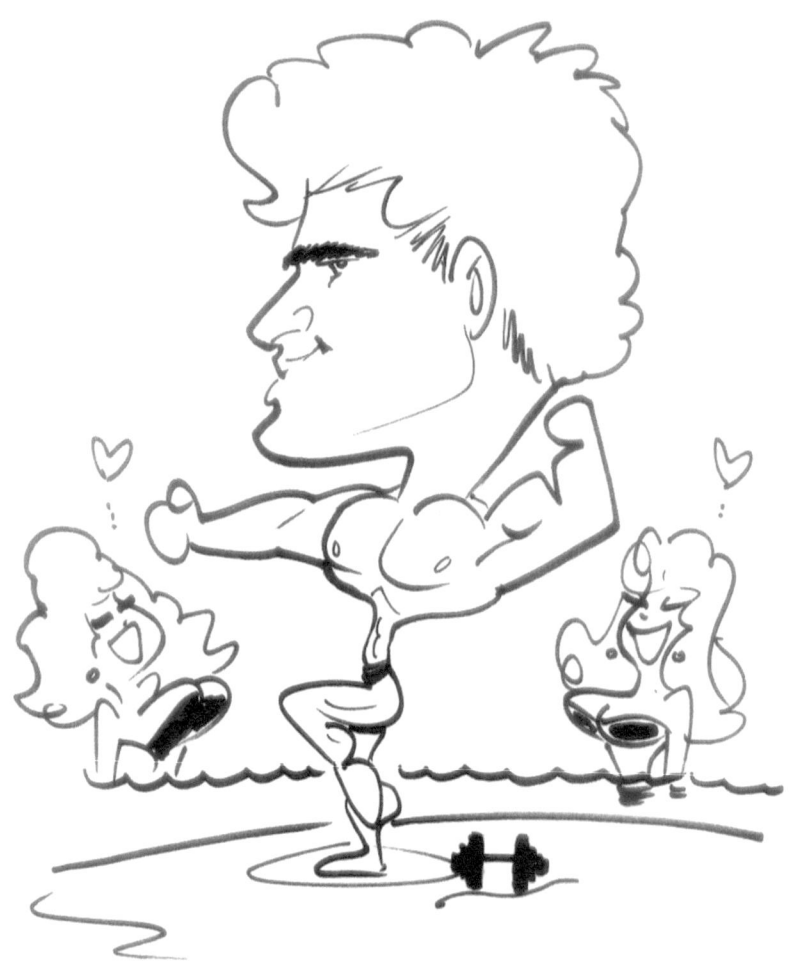

BODYBUILDING I

SPORTS

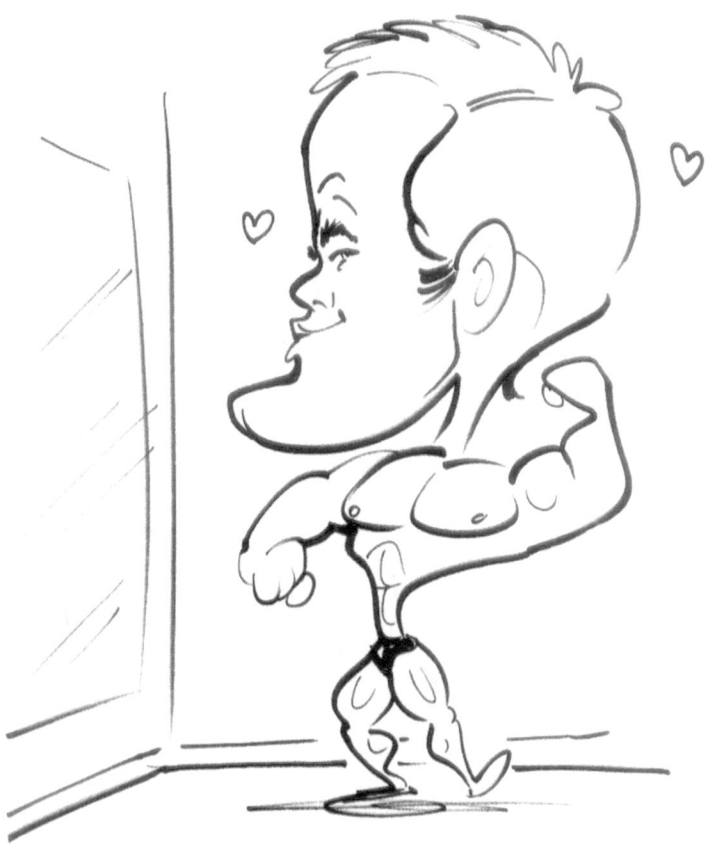

BODYBUILDING II

SPORTS

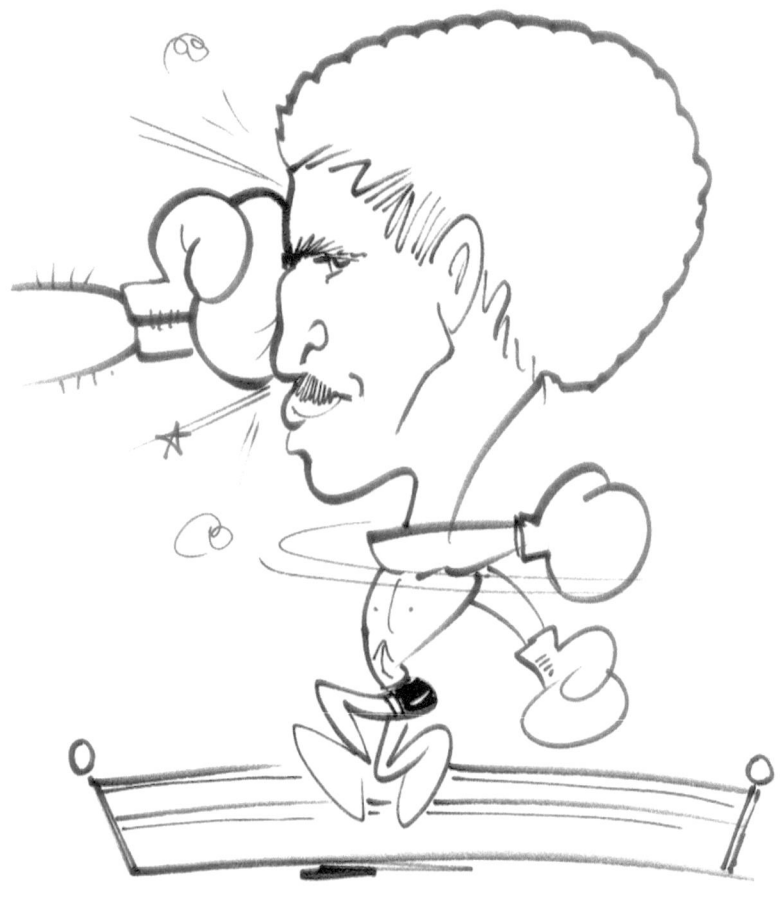

BOXING

SPORTS

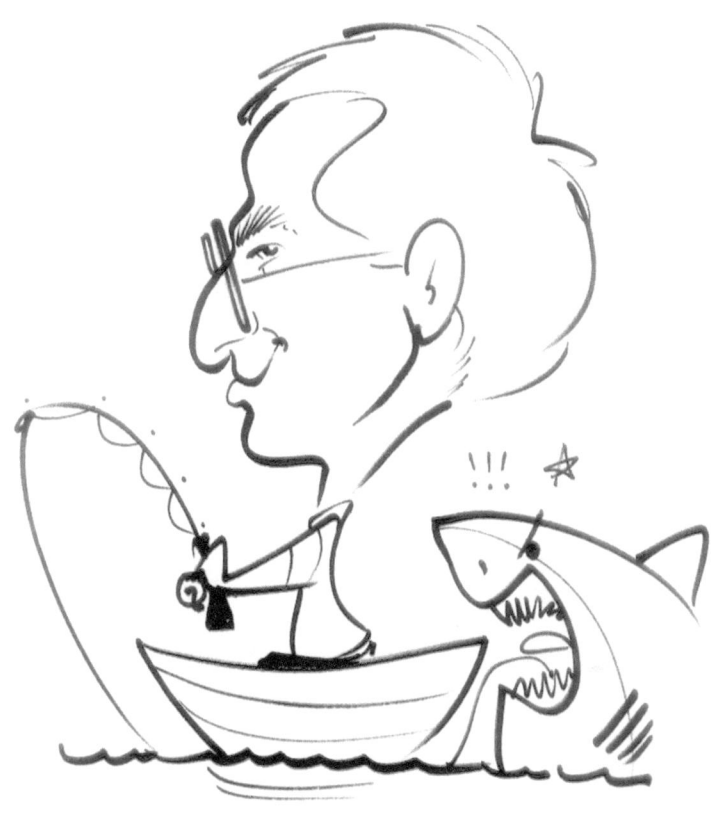

FISHING I

SPORTS

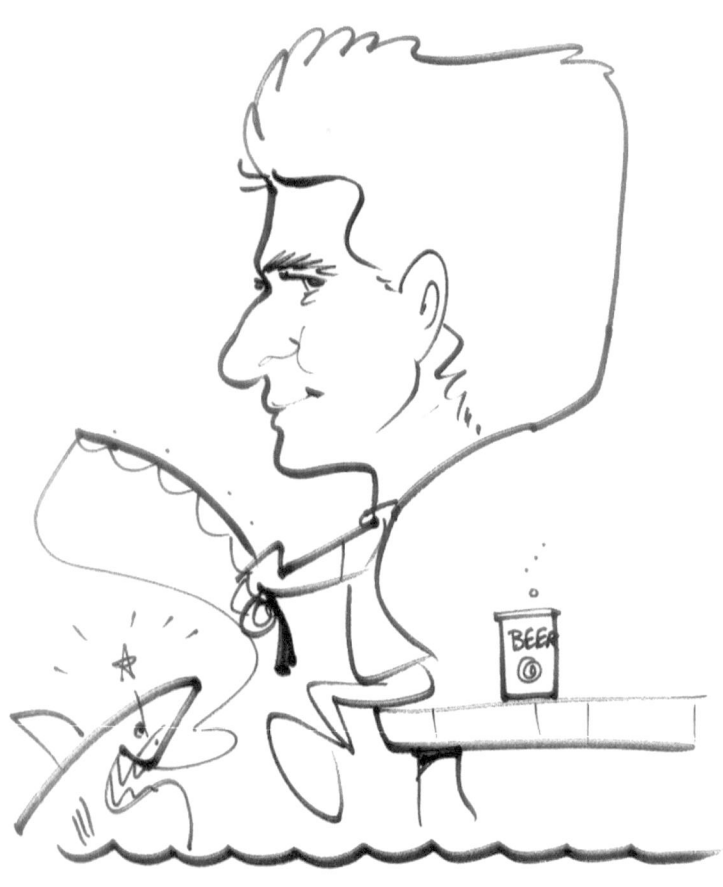

FISHING II

SPORTS

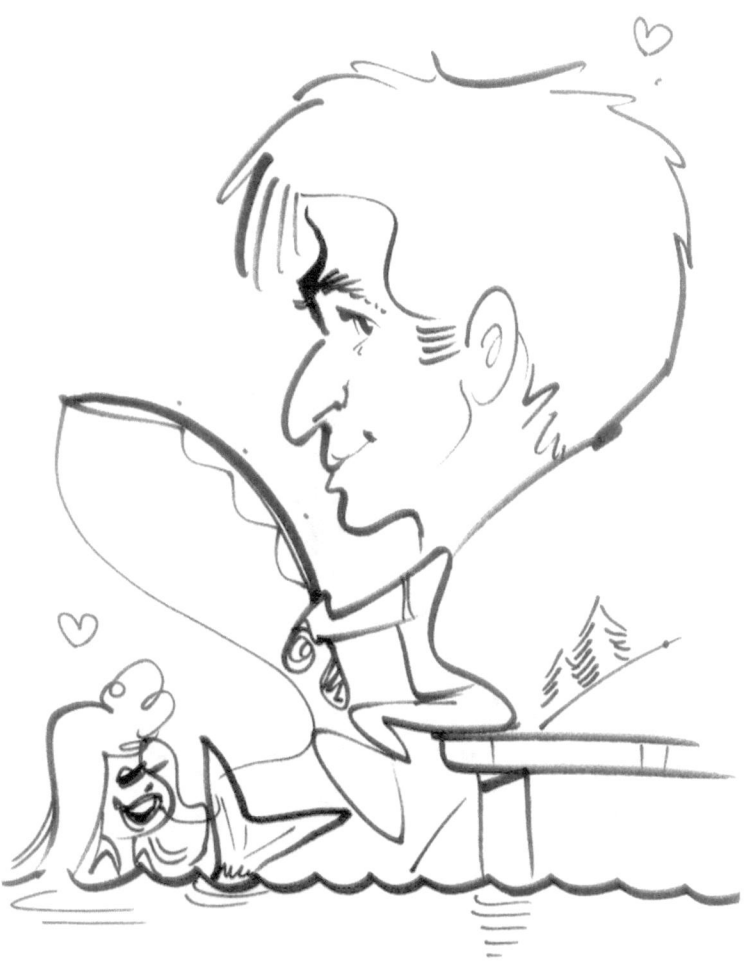

FISHING III

SPORTS

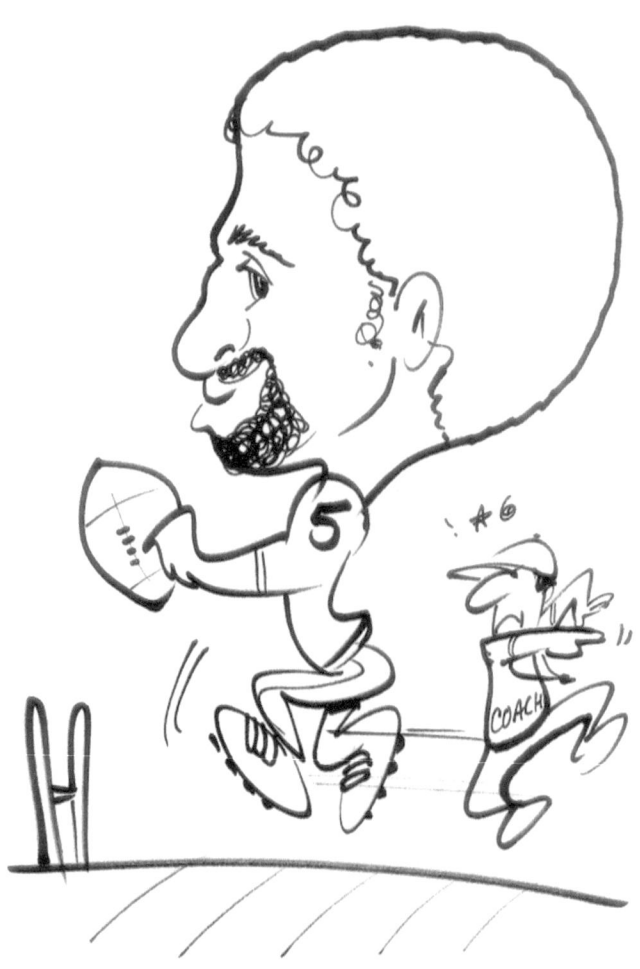

FOOTBALL 1

SPORTS

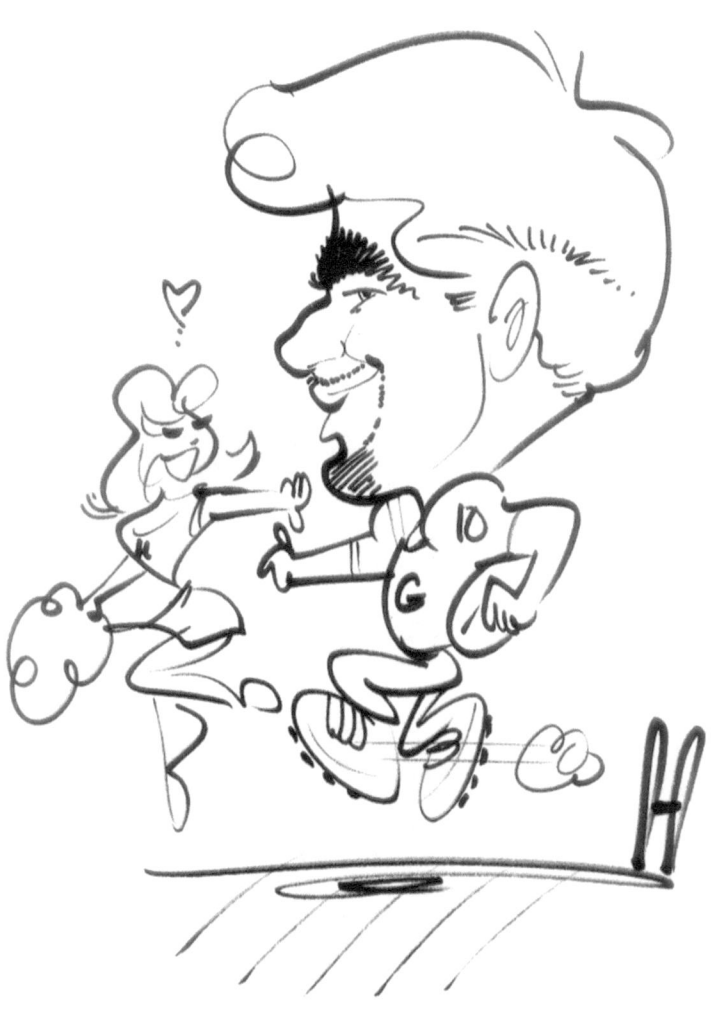

FOOTBALL II

SPORTS

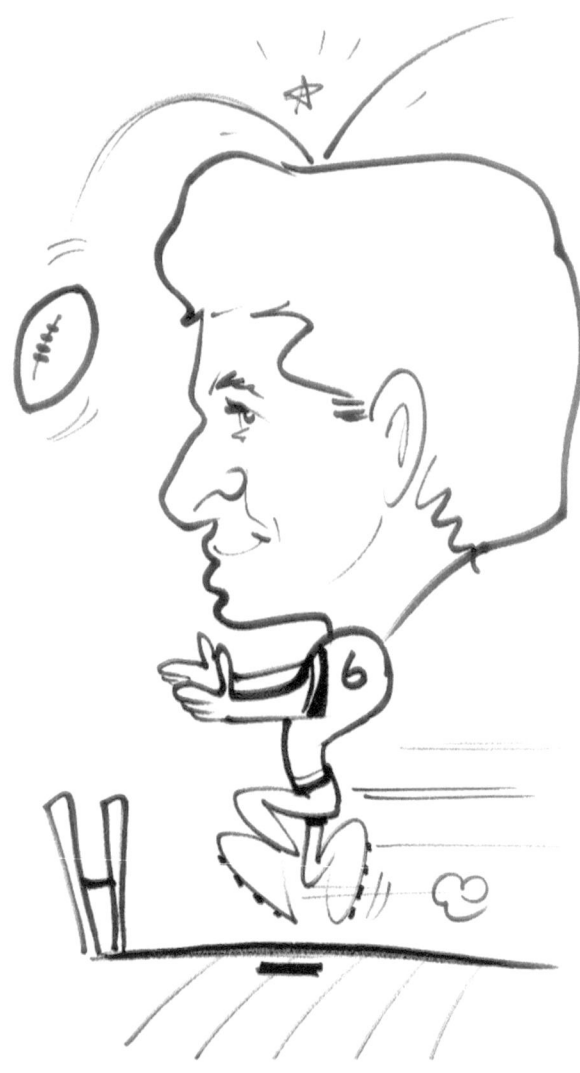

FOOTBALL III

SPORTS

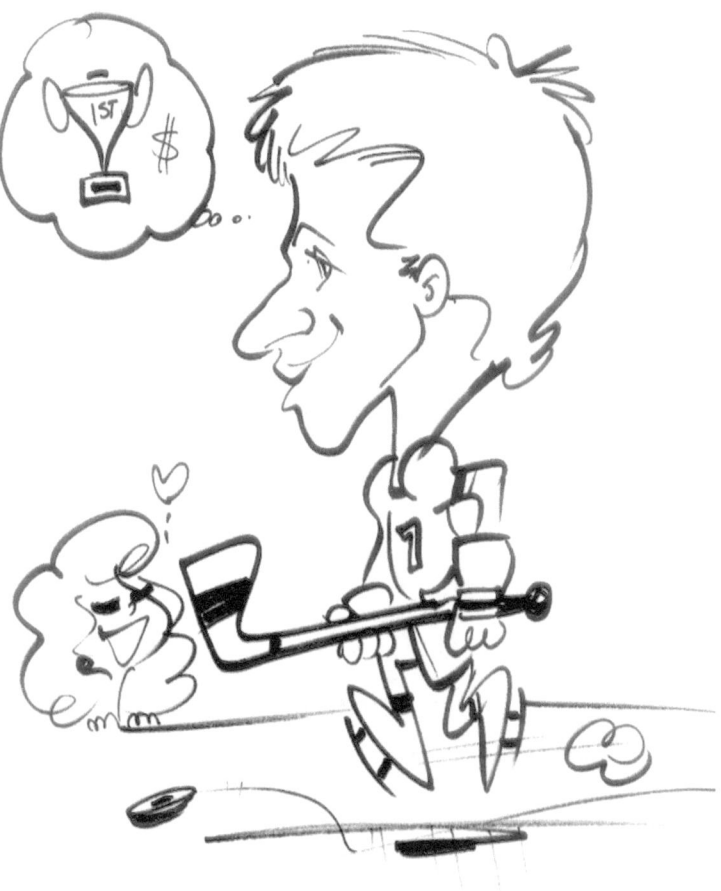

HOCKEY

SPORTS

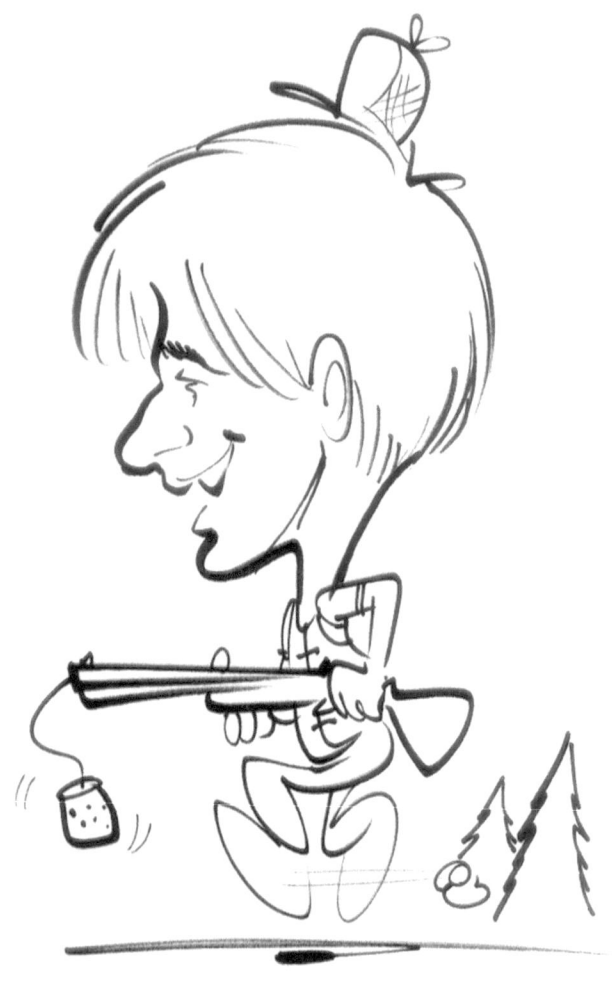

HUNTING 1

SPORTS

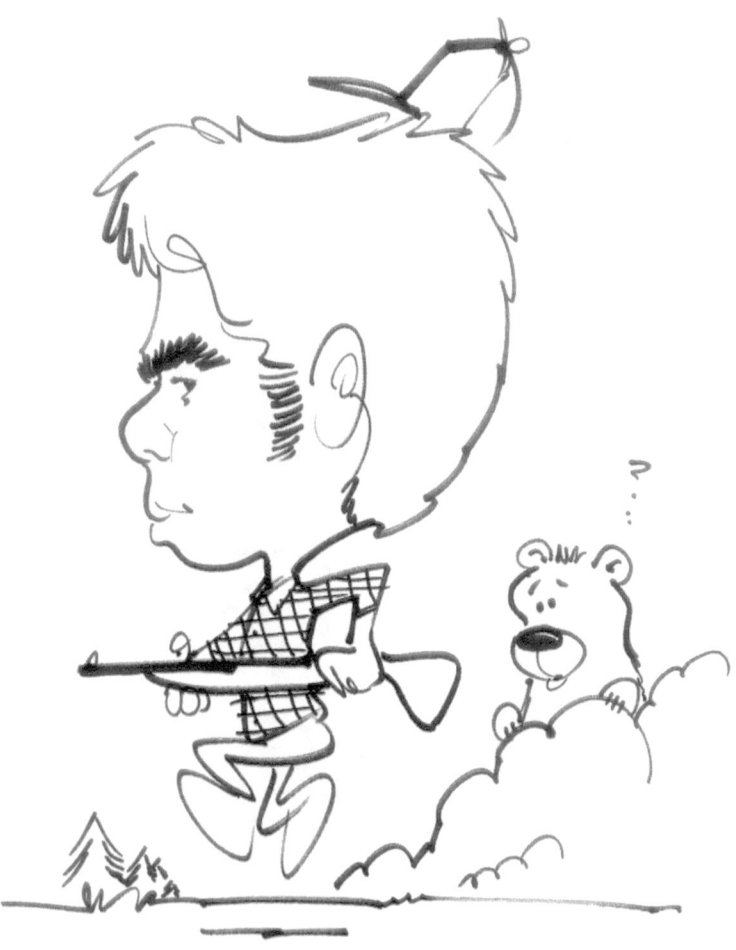

HUNTING II

SPORTS

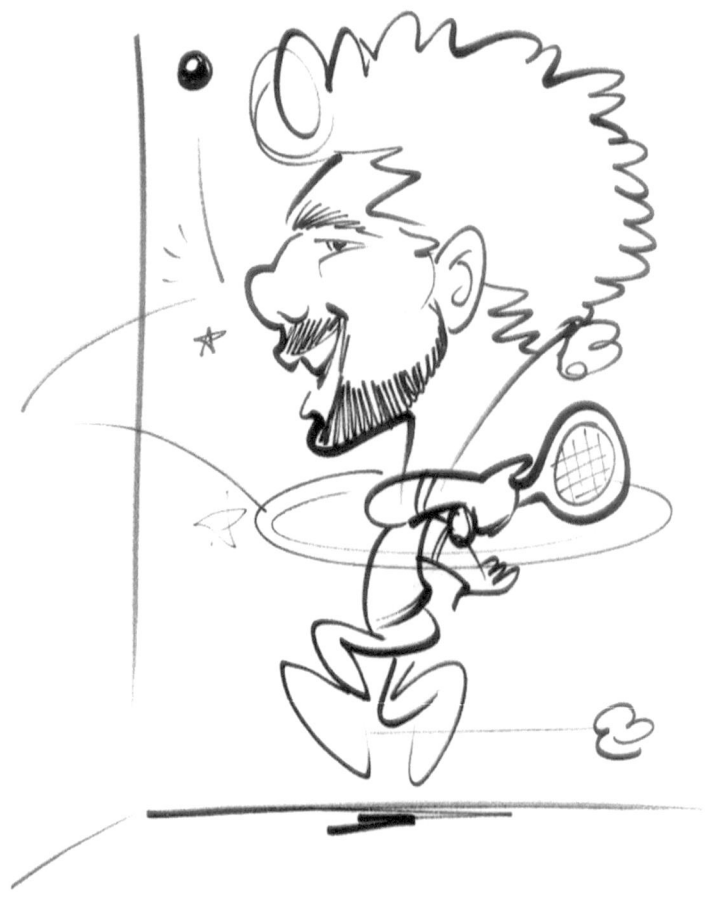

RAQUETBALL

SPORTS

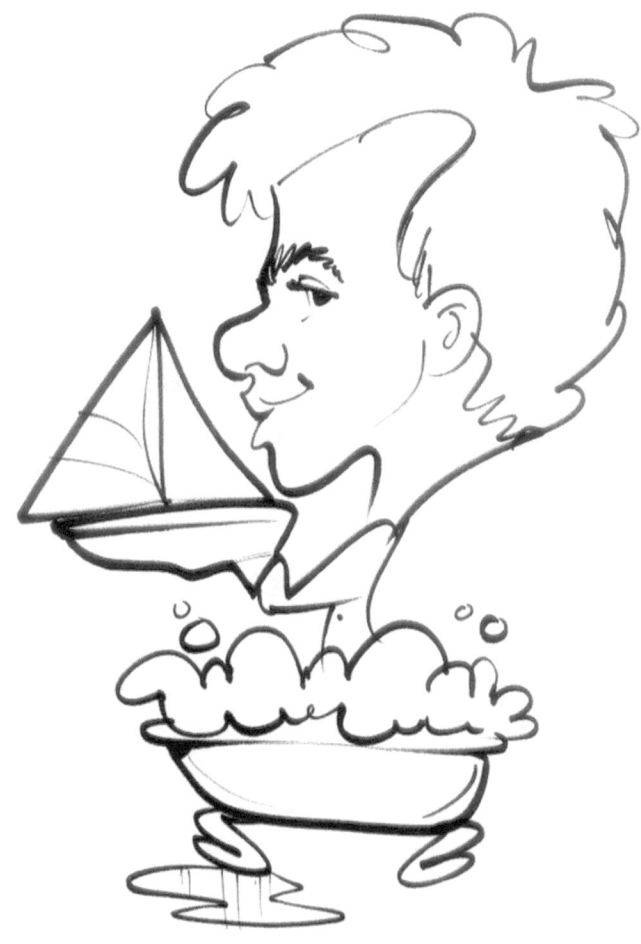

SAILING

SPORTS

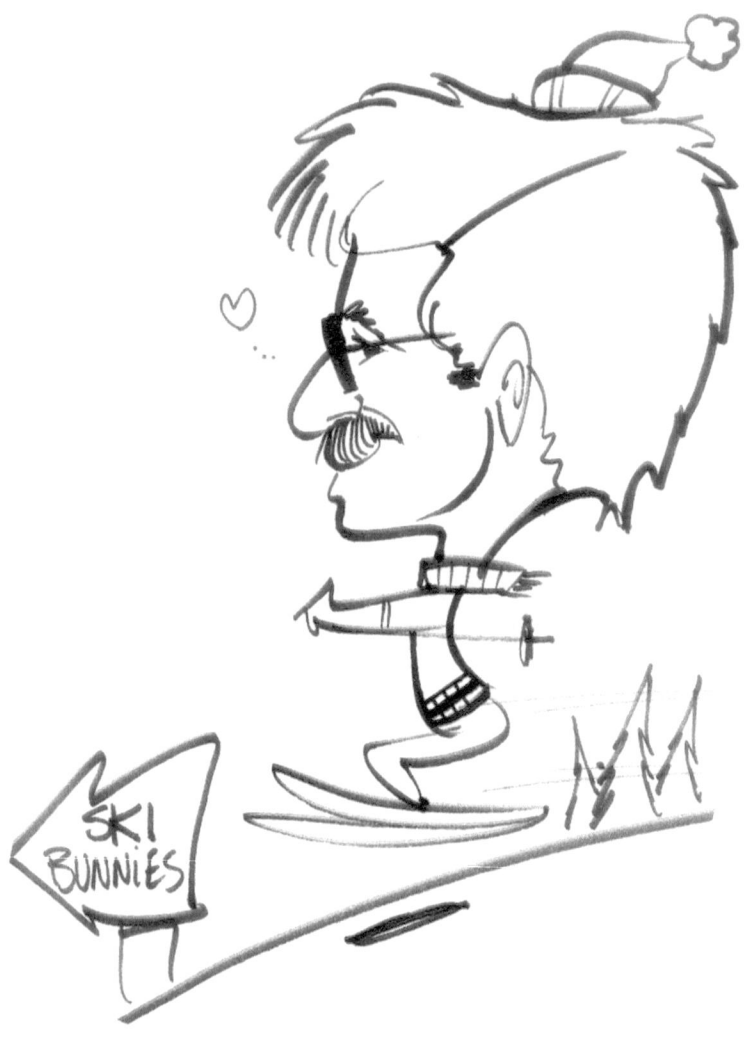

SKIING I

SPORTS

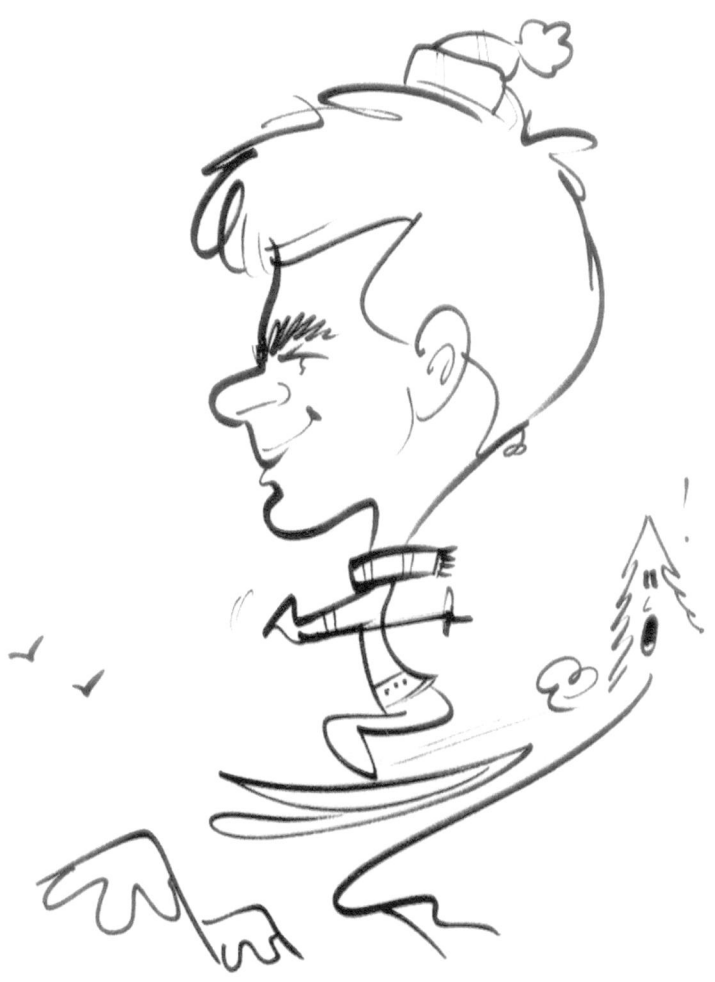

SKIING II

SPORTS

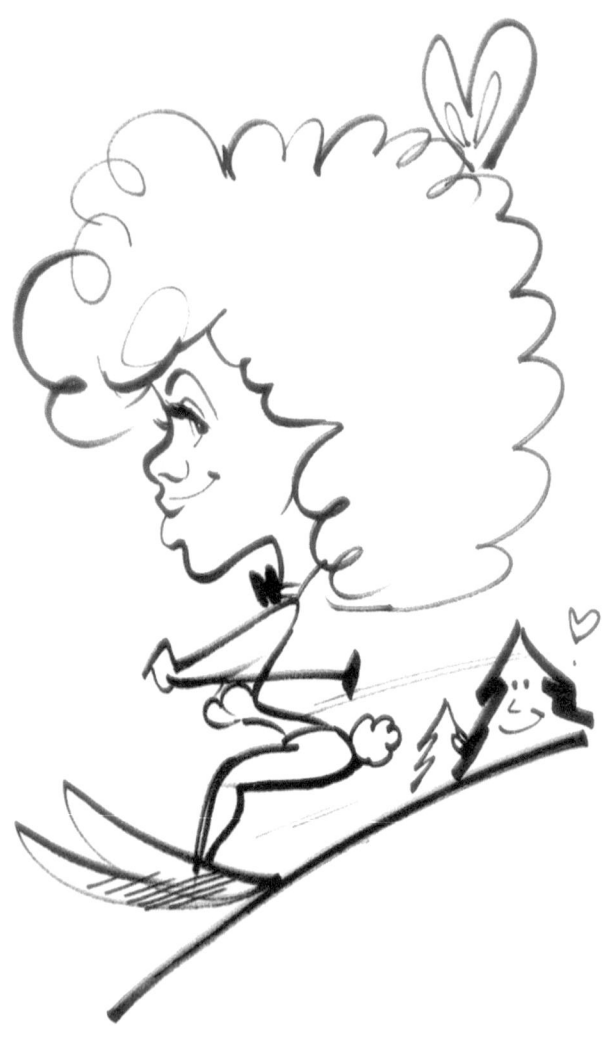

SKI BUNNY

SPORTS

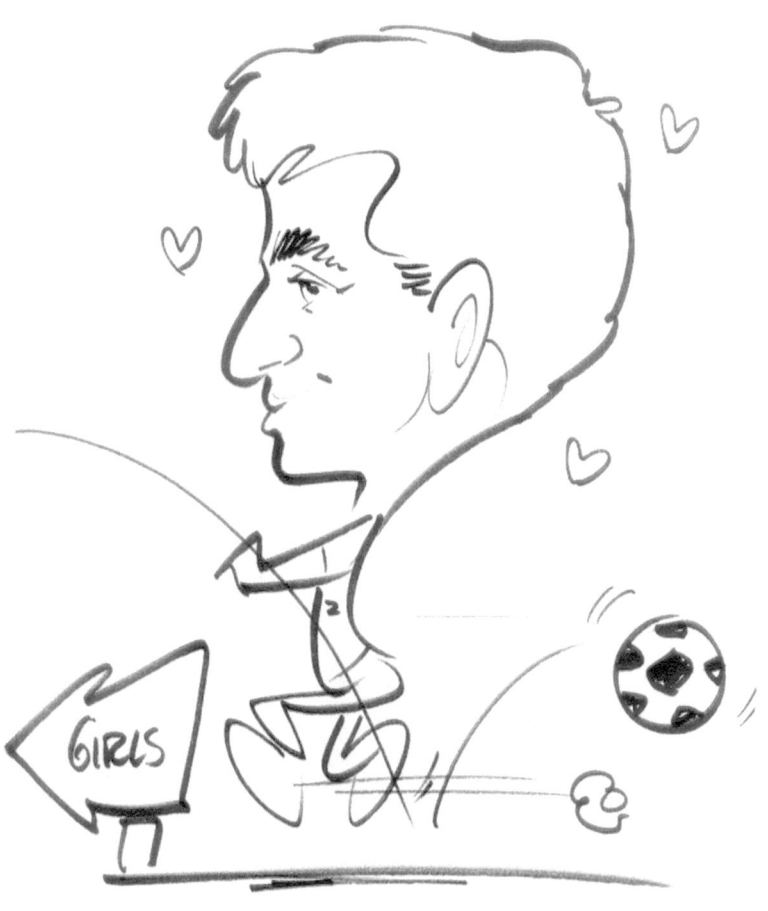

SOCCER 1

SPORTS

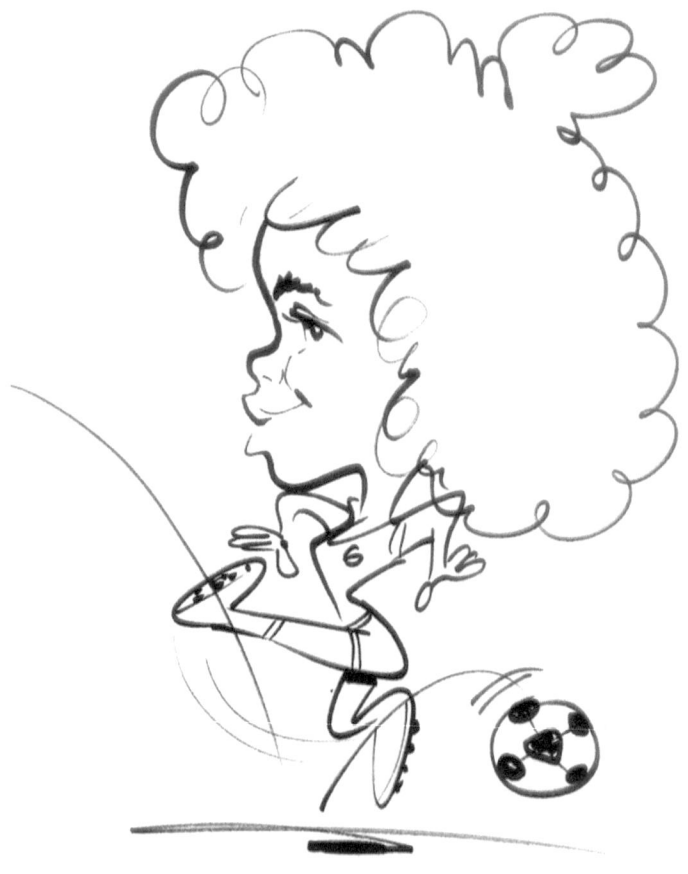

Soccer II

SPORTS

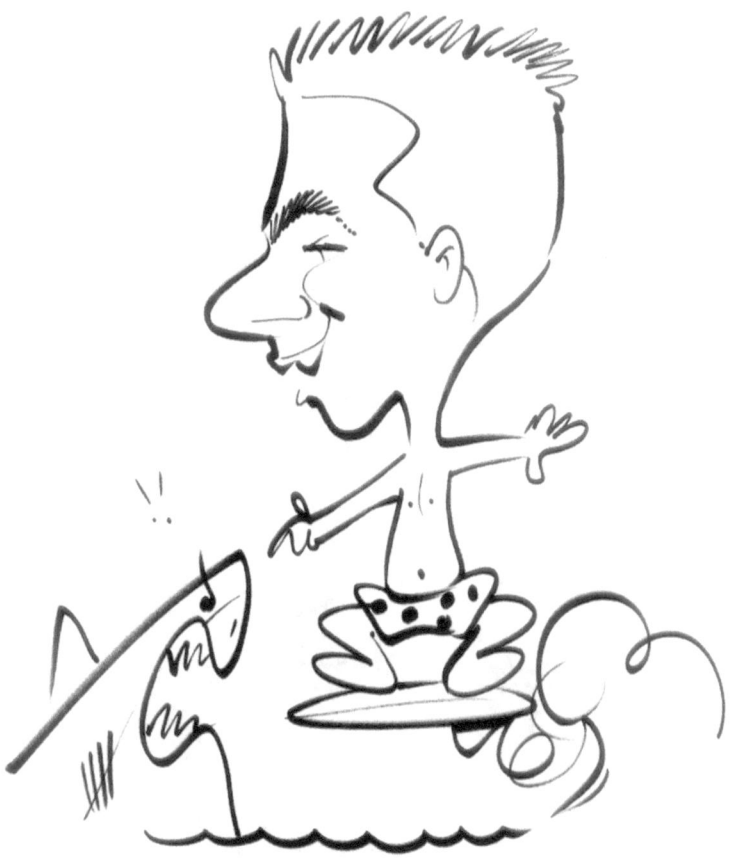

SURFING 1

SPORTS

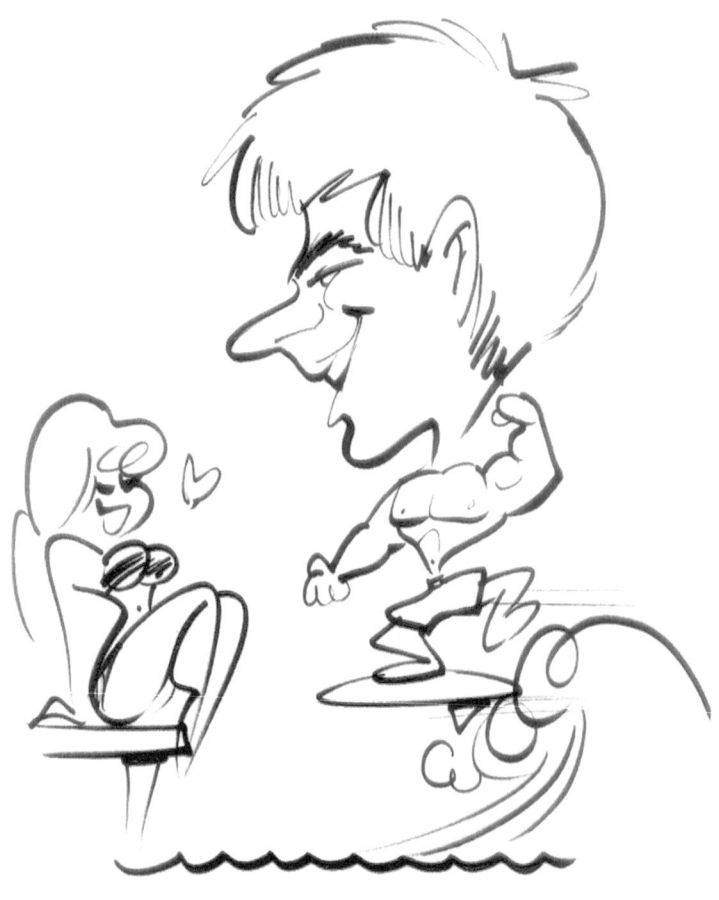

SURFING II

SPORTS

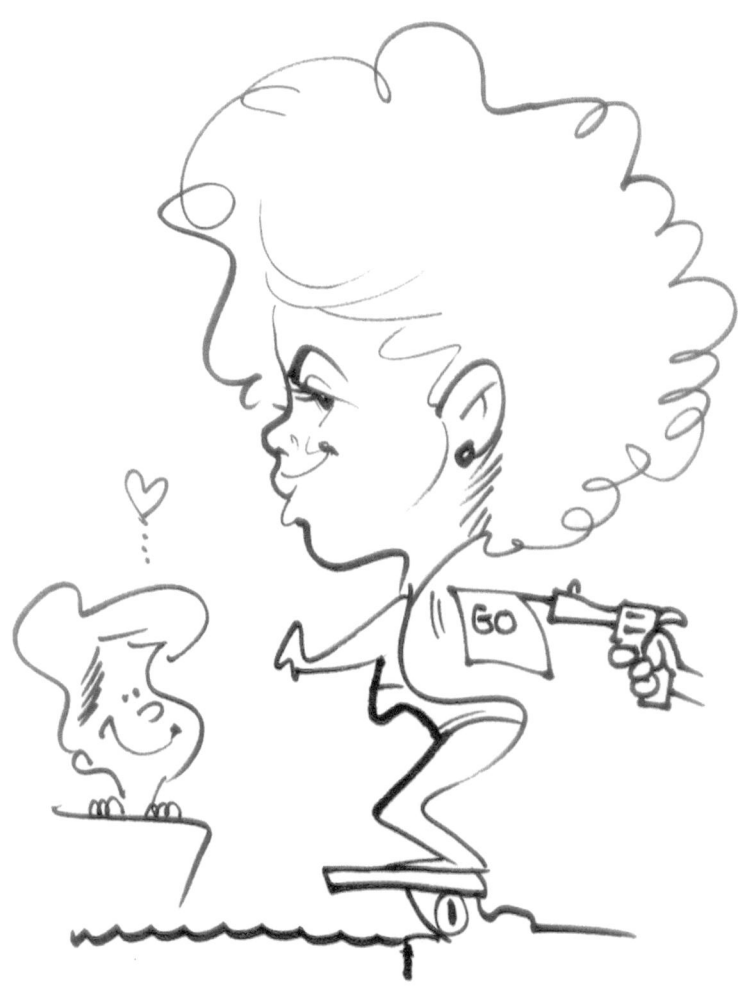

SWIMMING

SPORTS

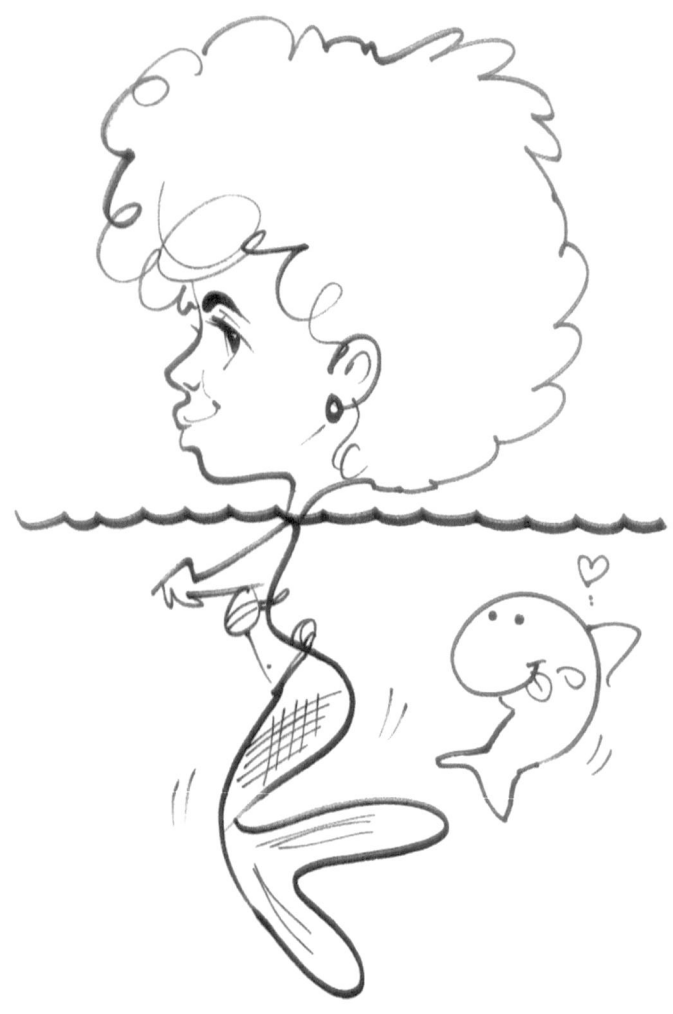

SWIMMING/MERMAID

SPORTS

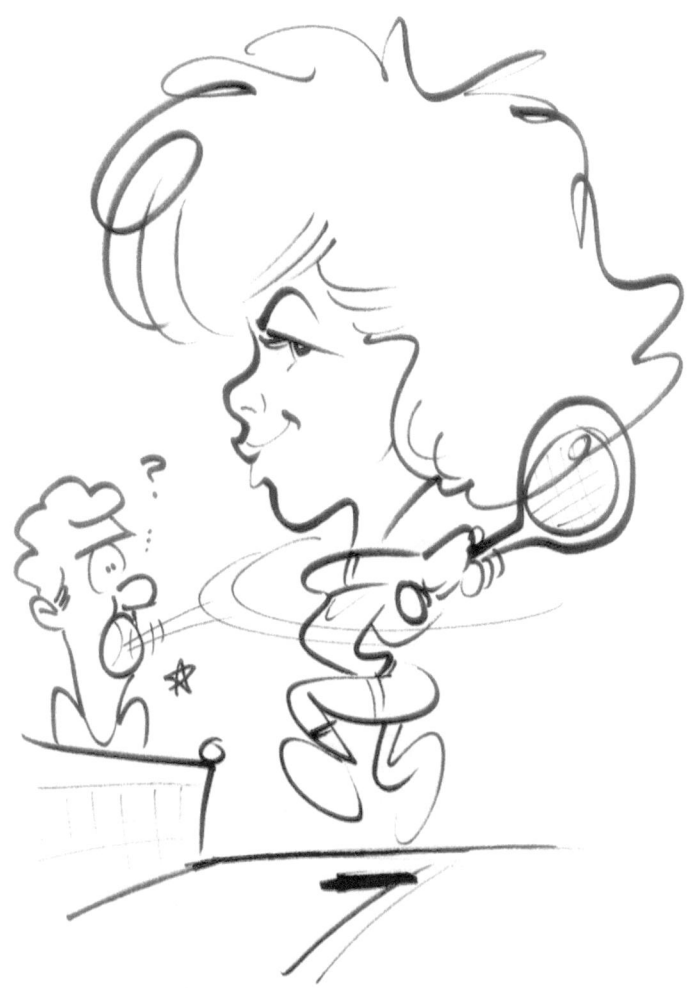

TENNIS 1

35

SPORTS

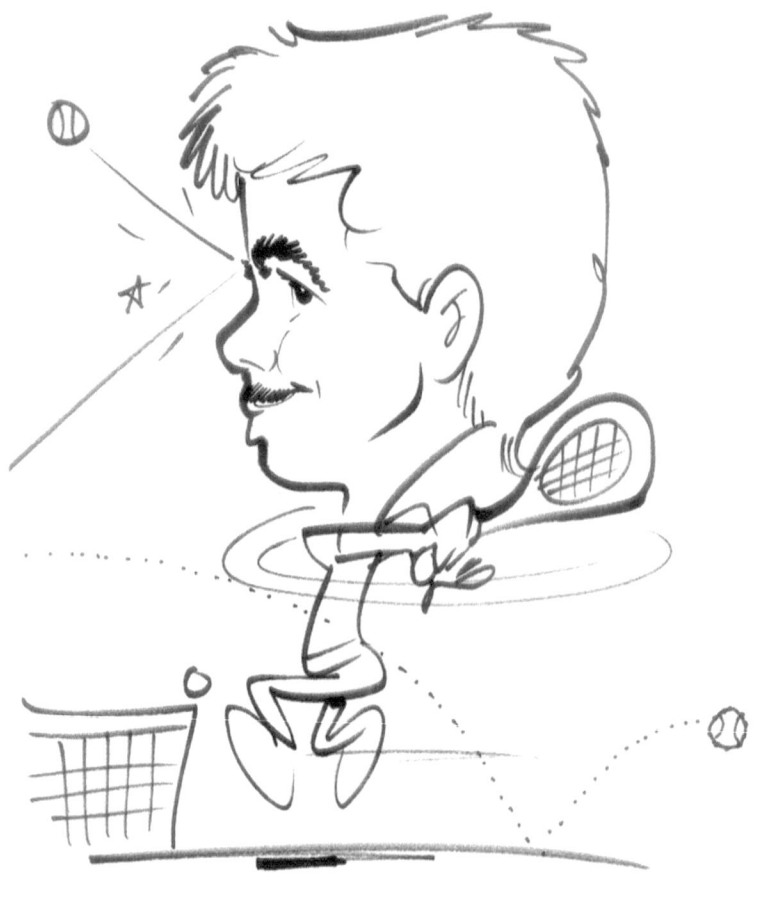

TENNIS II

SPORTS

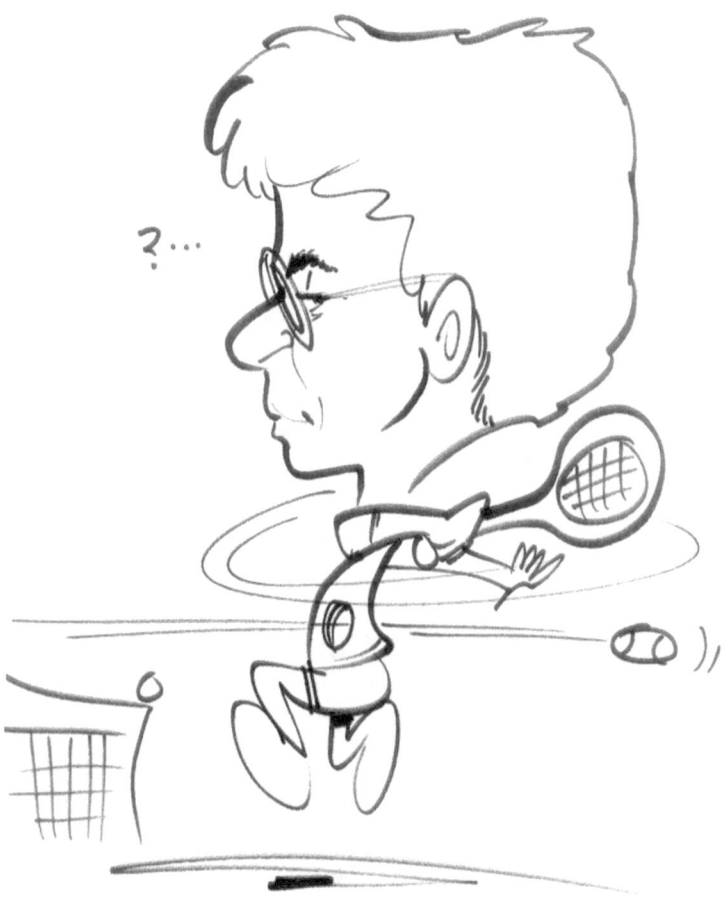

TENNIS III

SPORTS

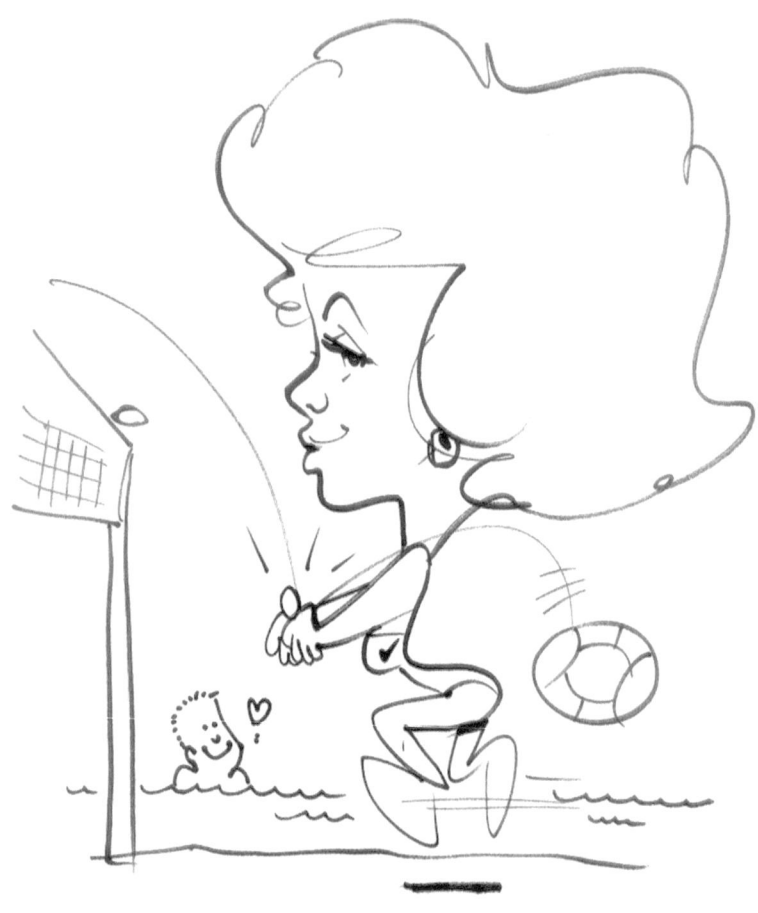

VOLLEYBALL

SPORTS

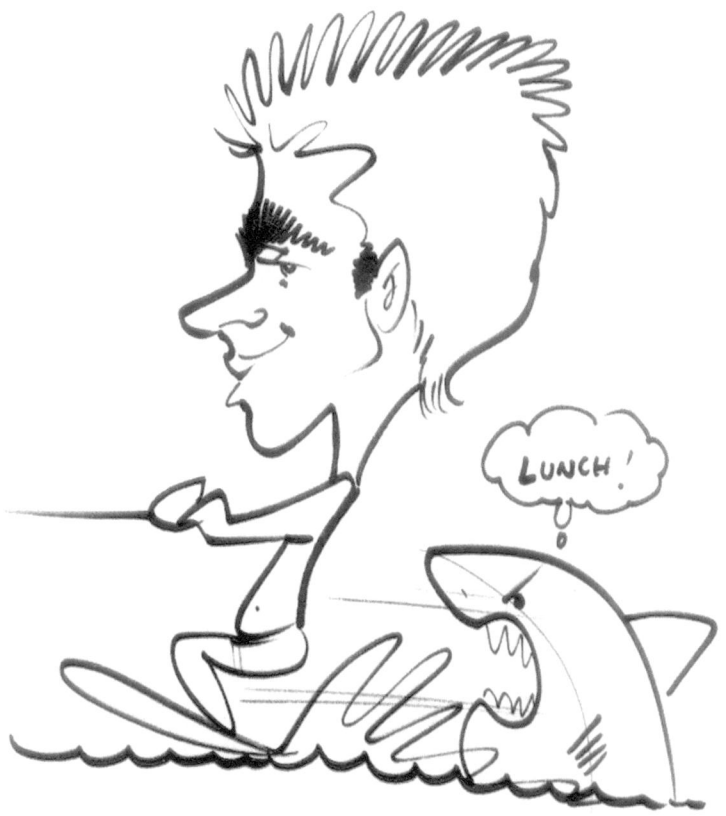

WATERSKIING 1

SPORTS

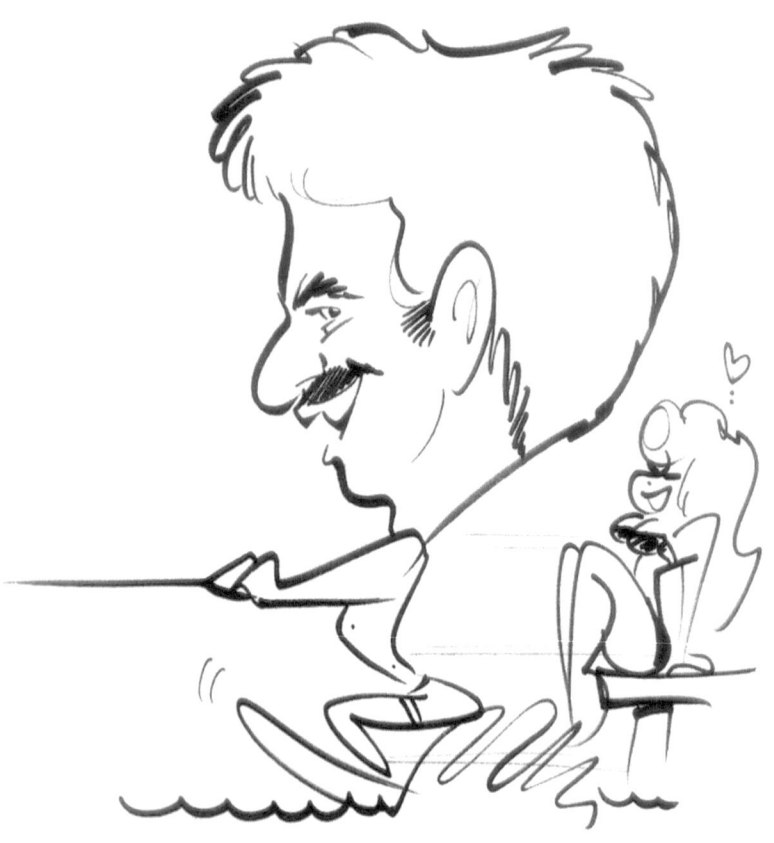

WATERSKIING II

SPORTS

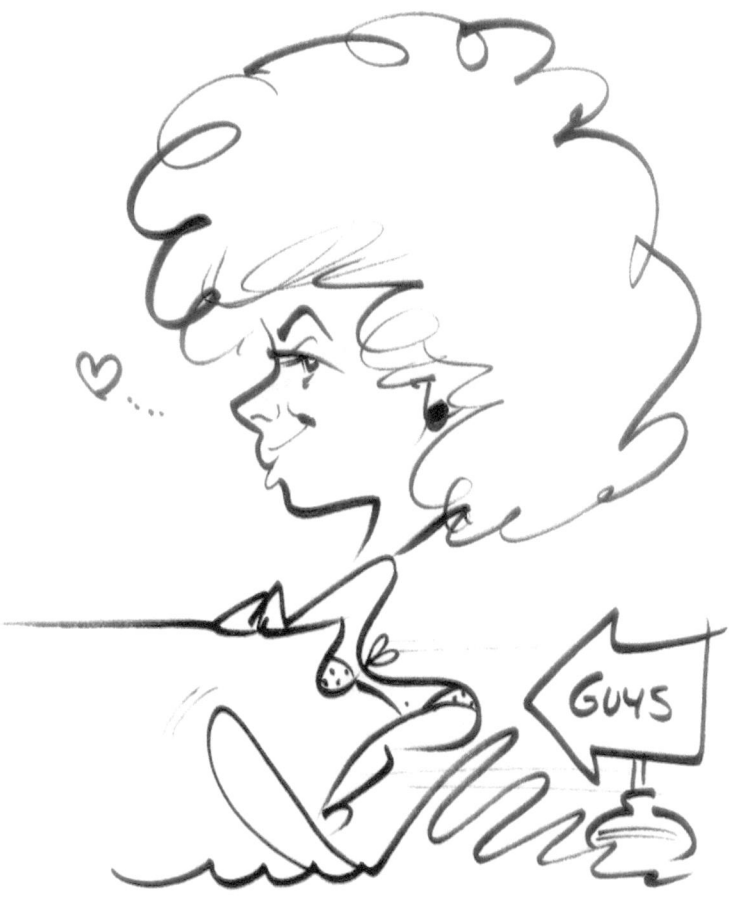

WATERSKIING III

SPORTS

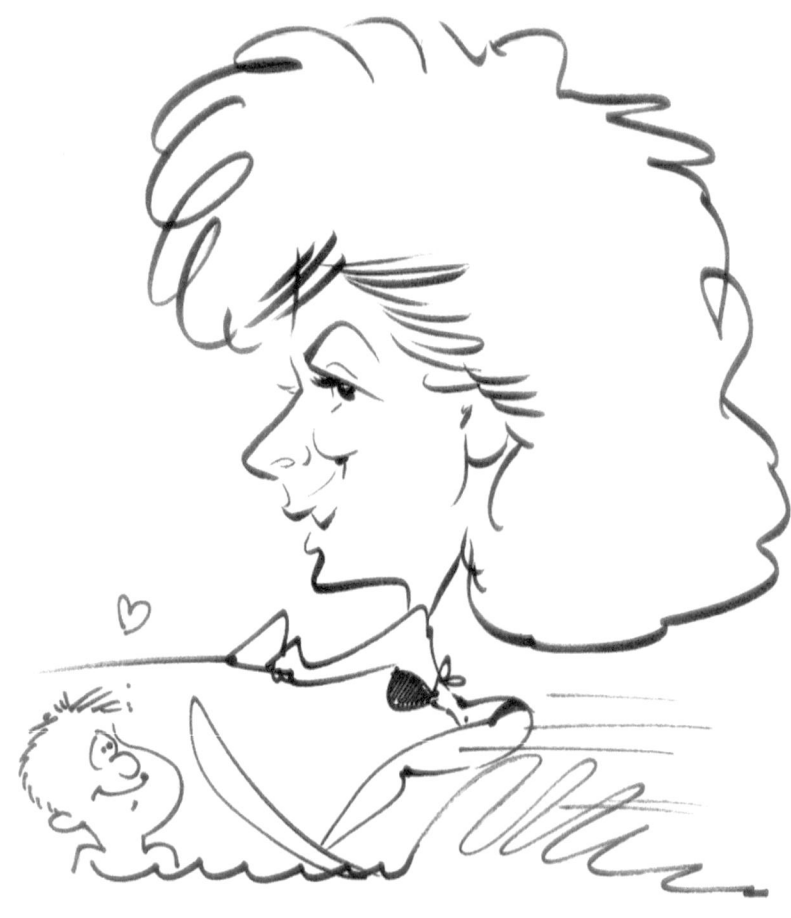

WATERSKIING IV

SPORTS

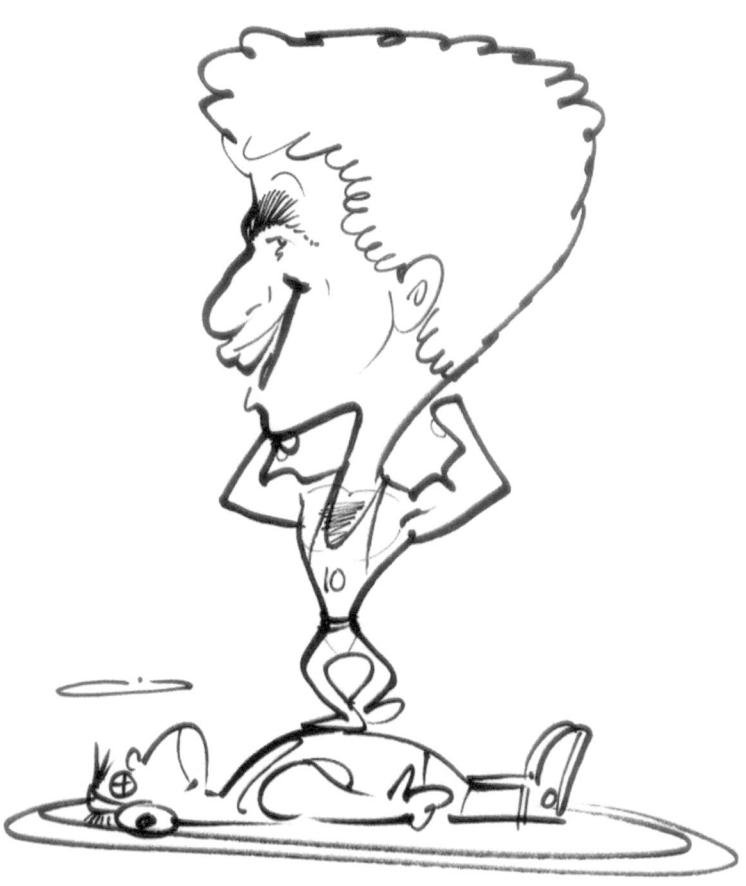

WRESTLING

HOBBIES

HOBBIES

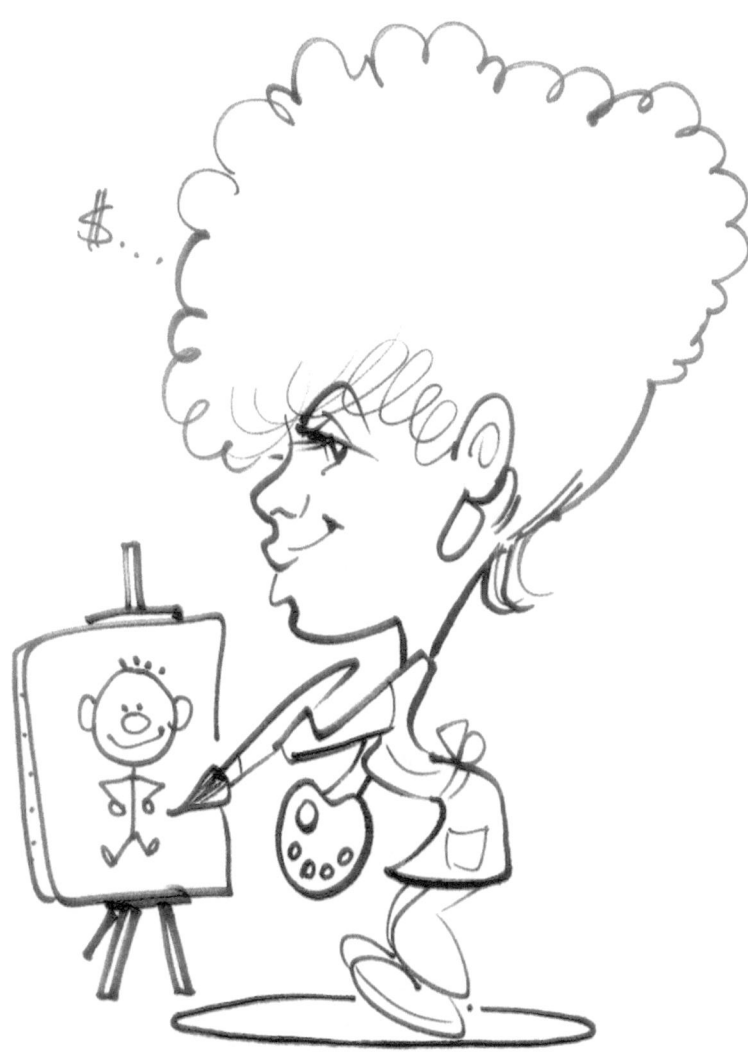

ARTIST

HOBBIES

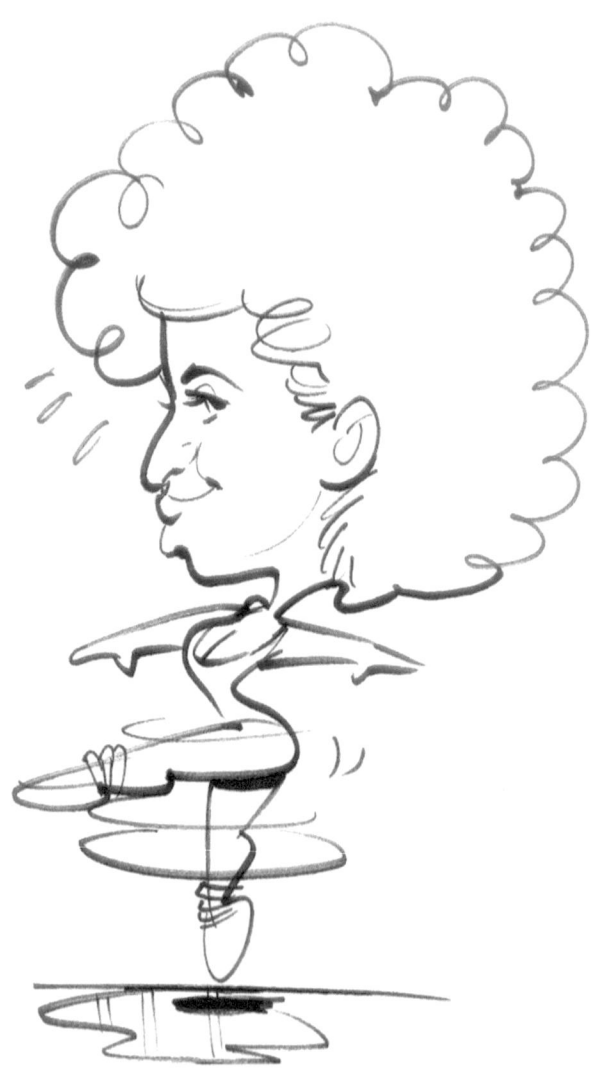

AEROBICS

HOBBIES

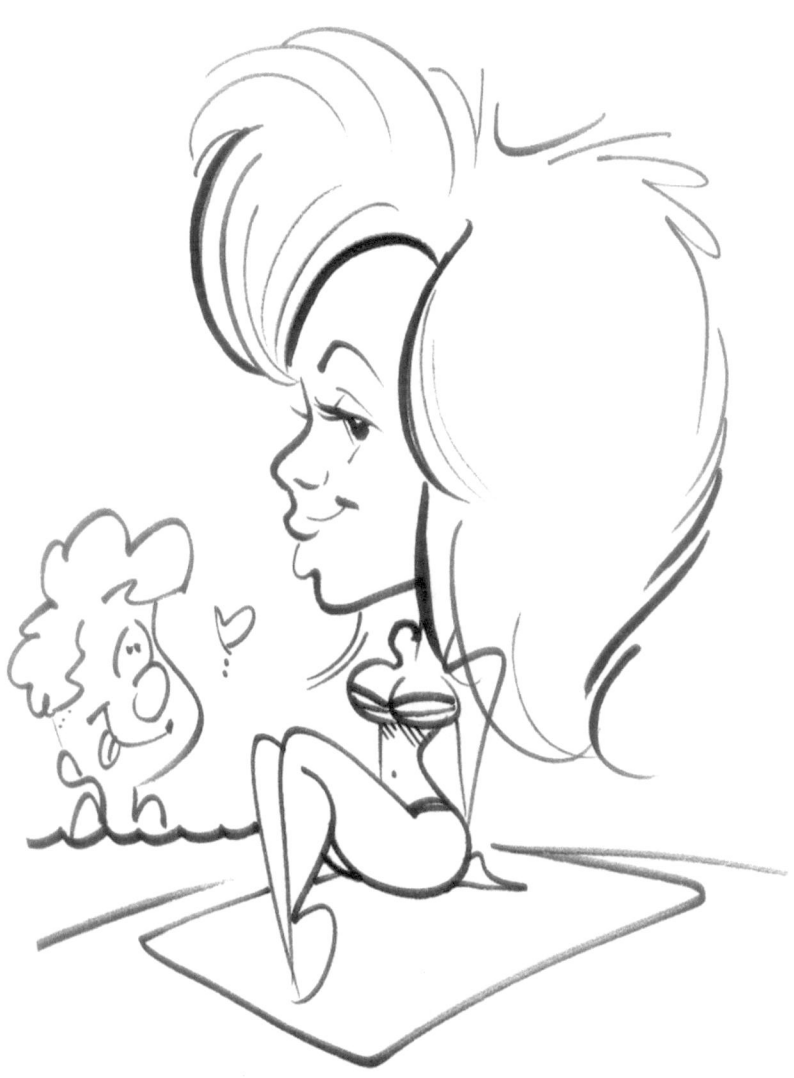

BEACH/SUNTANNING

HOBBIES

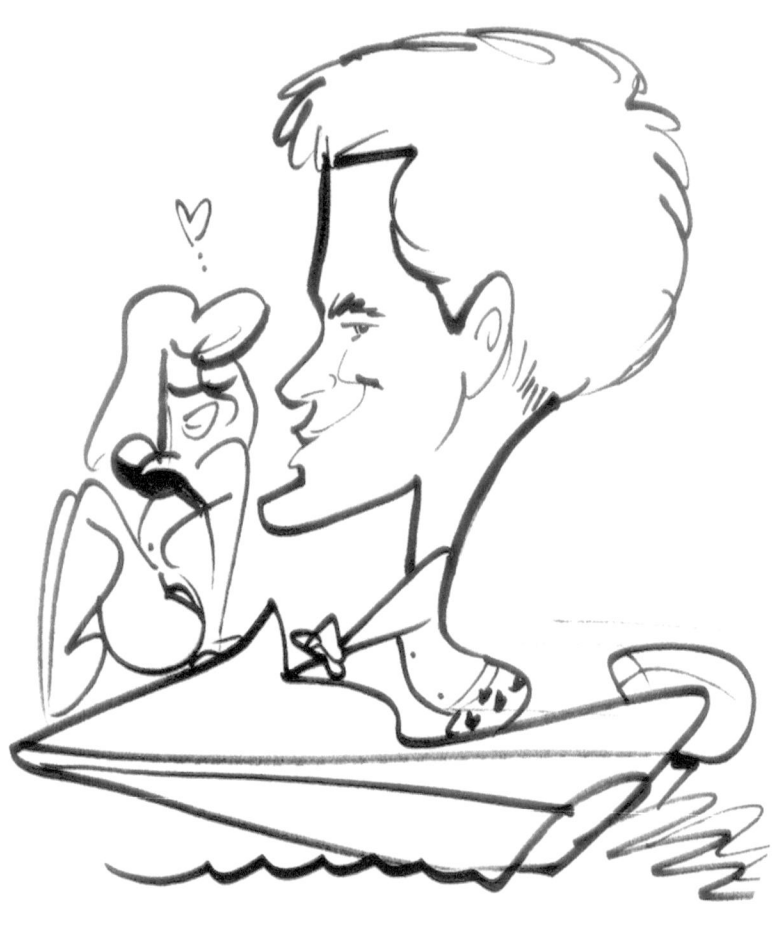

BOATS

HOBBIES

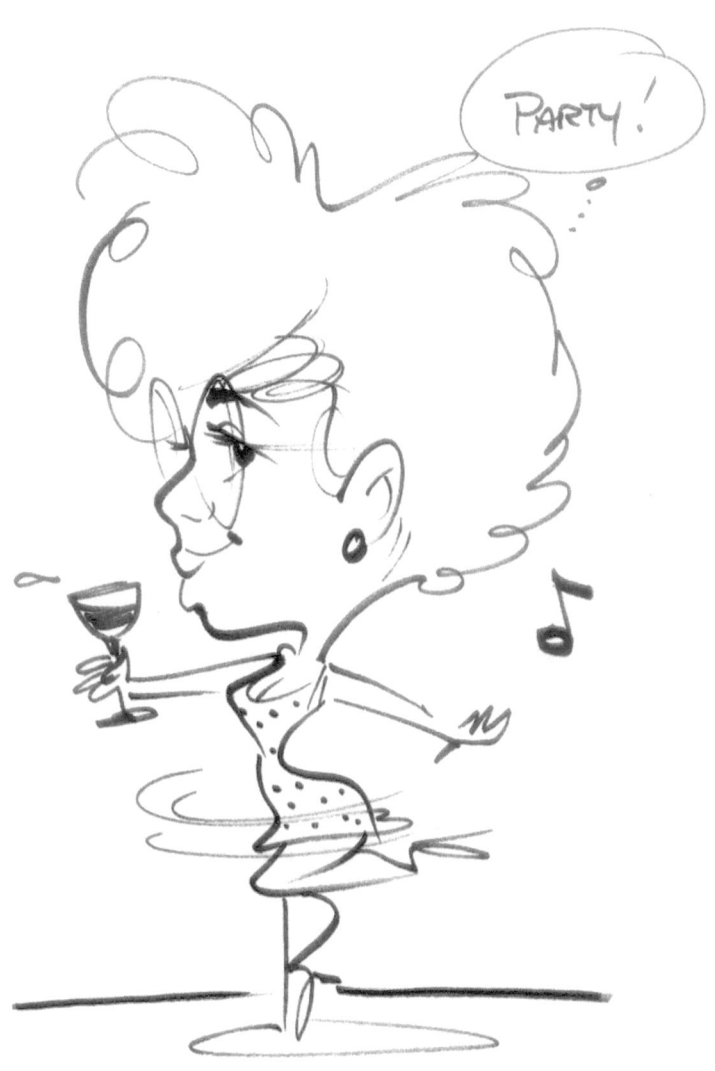

DANCING/PARTYING

HOBBIES

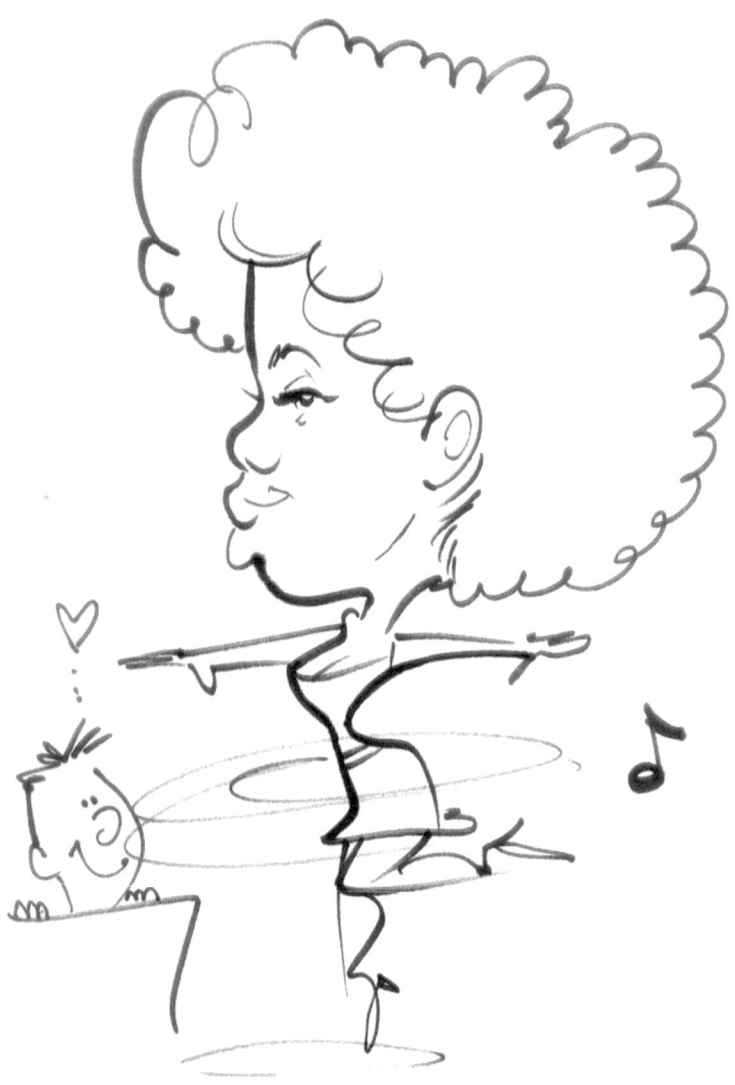

DANCING

HOBBIES

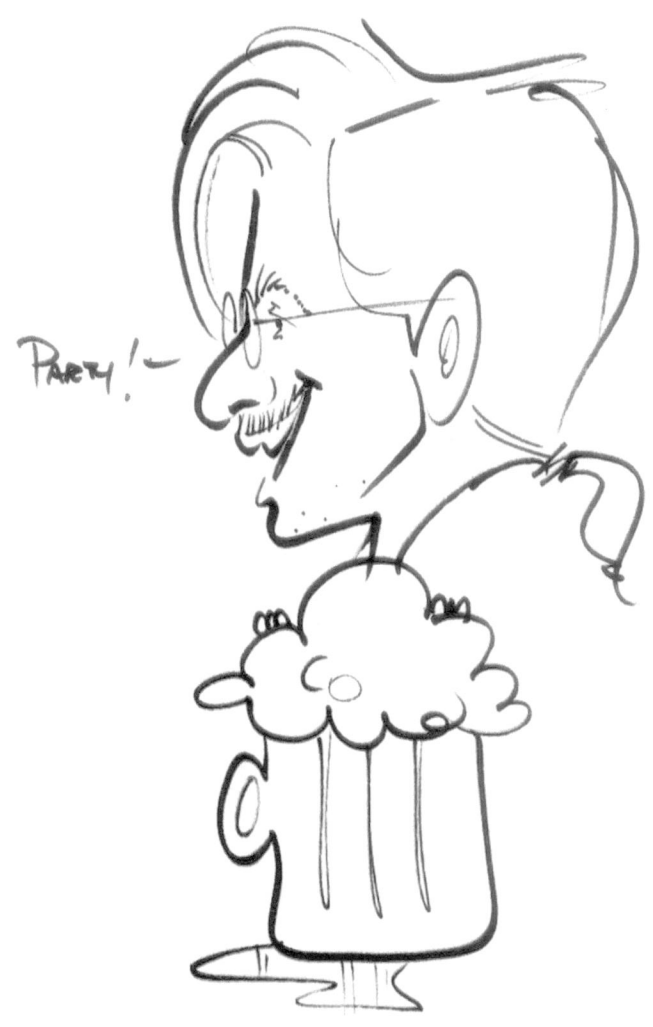

DRINKING 1

HOBBIES

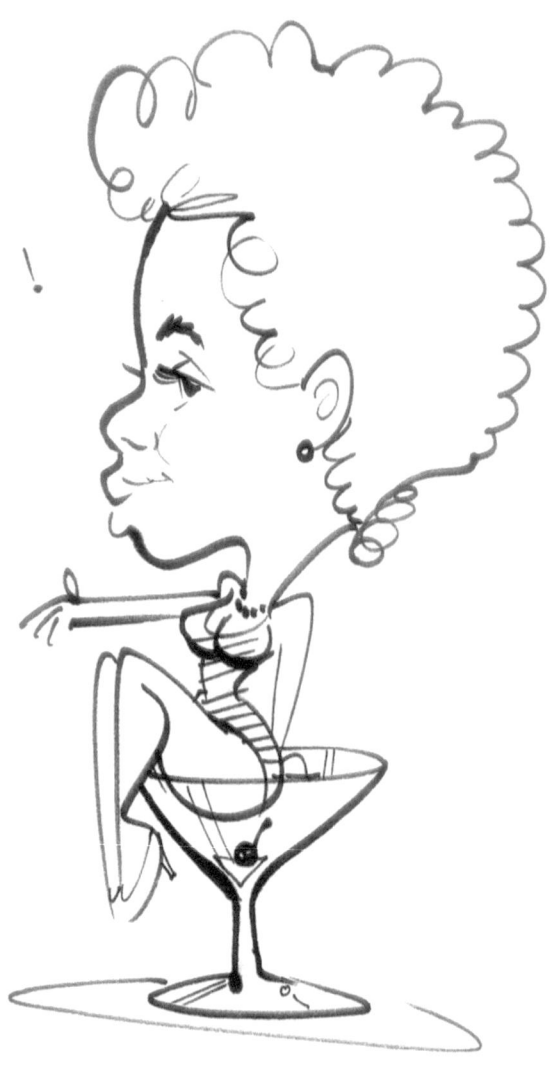

DRINKING II

HOBBIES

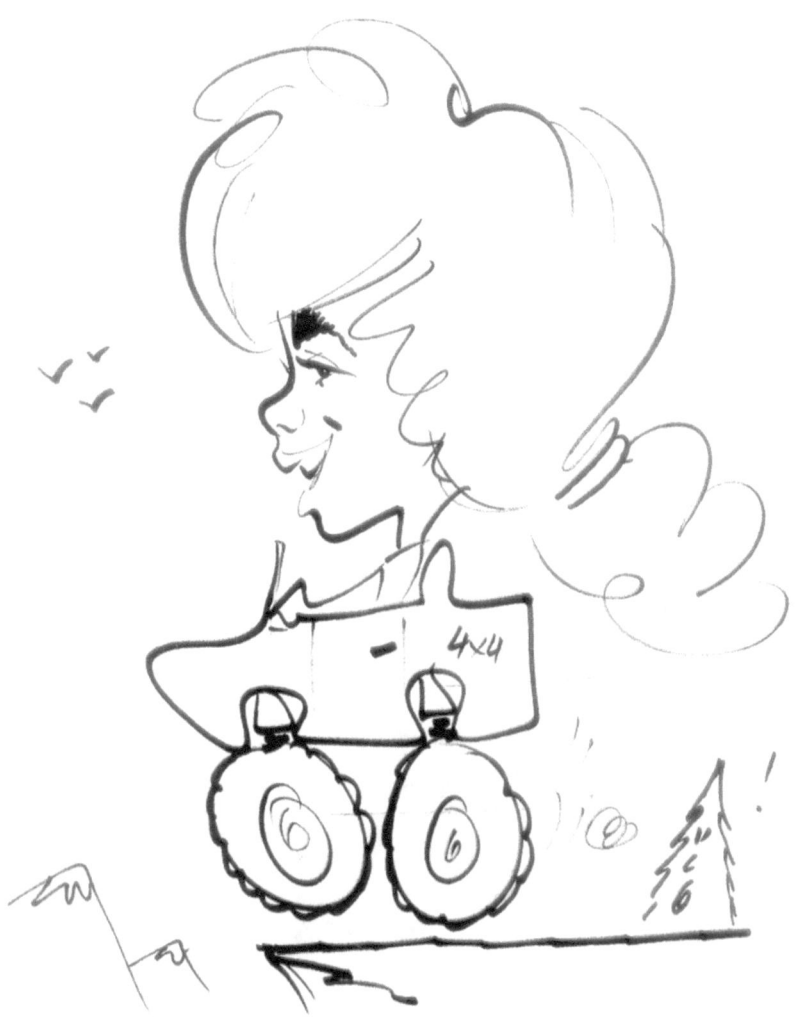

DRIVING I

HOBBIES

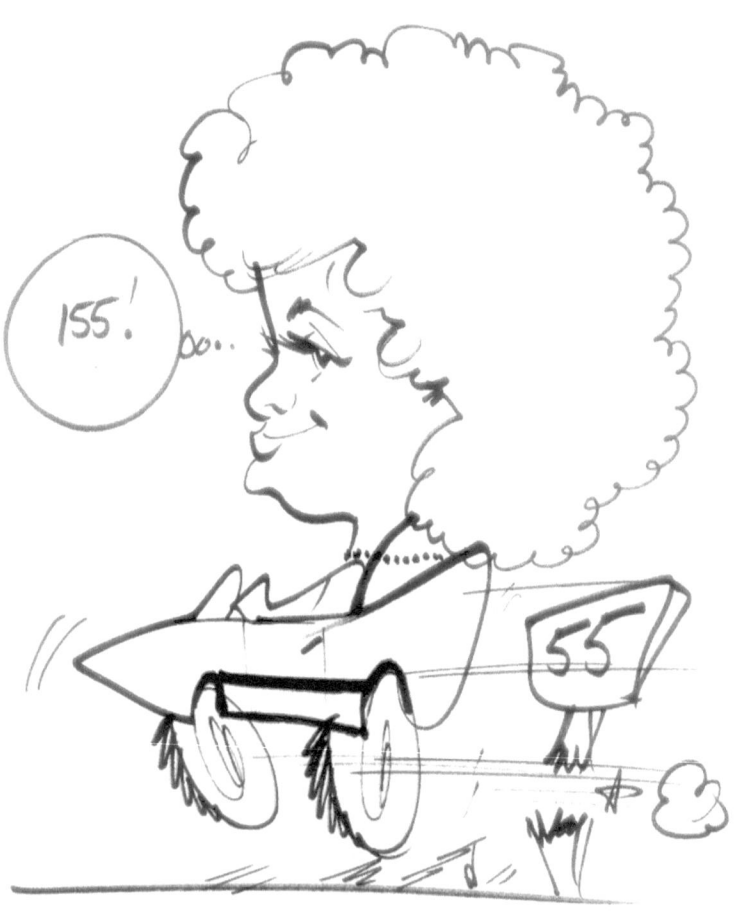

DRIVING II

HOBBIES

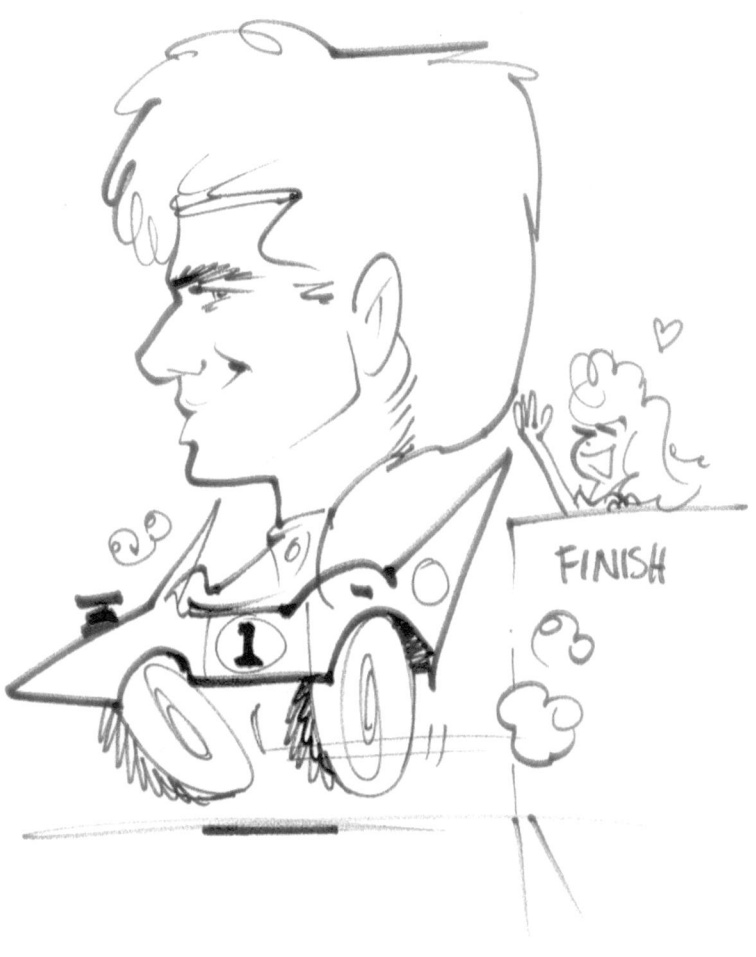

DRIVING III

HOBBIES

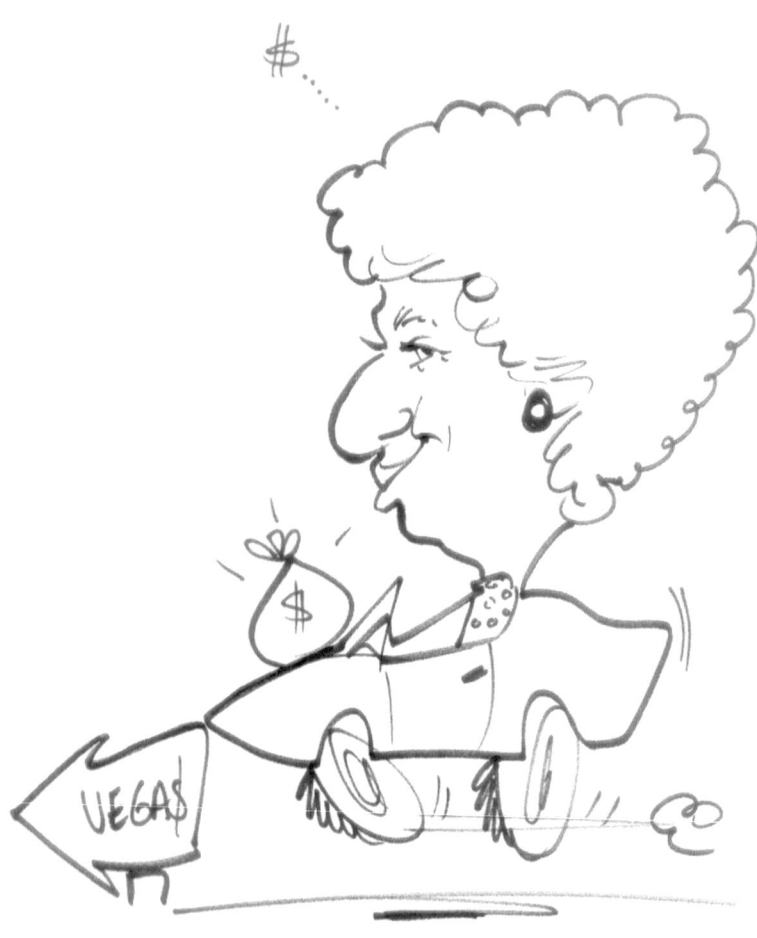

GAMBLING I

HOBBIES

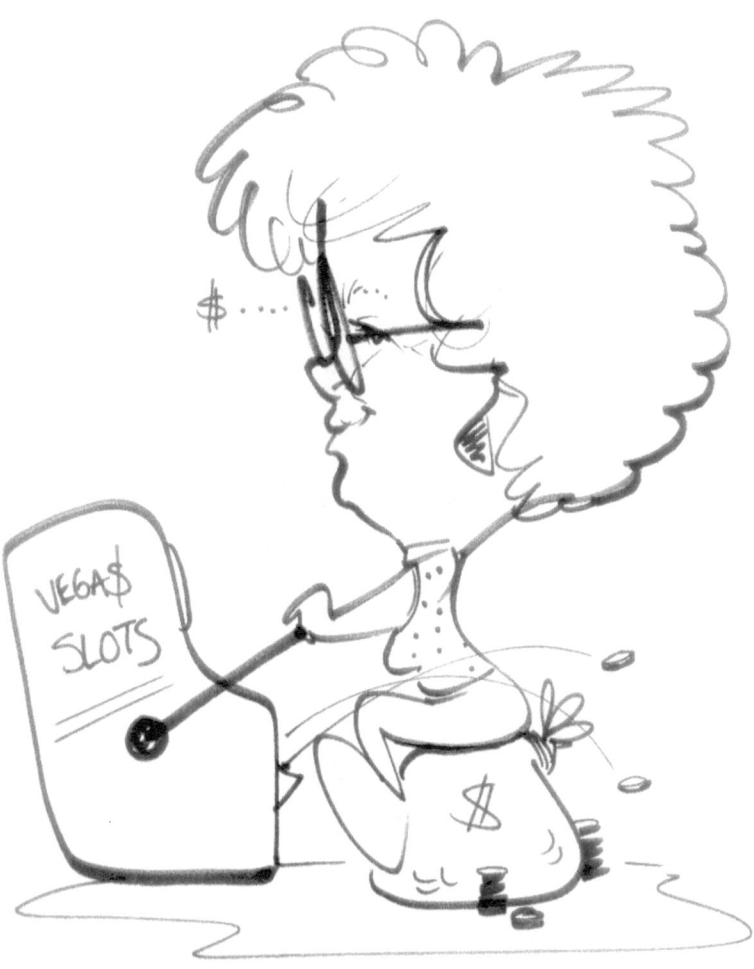

GAMBLING II

HOBBIES

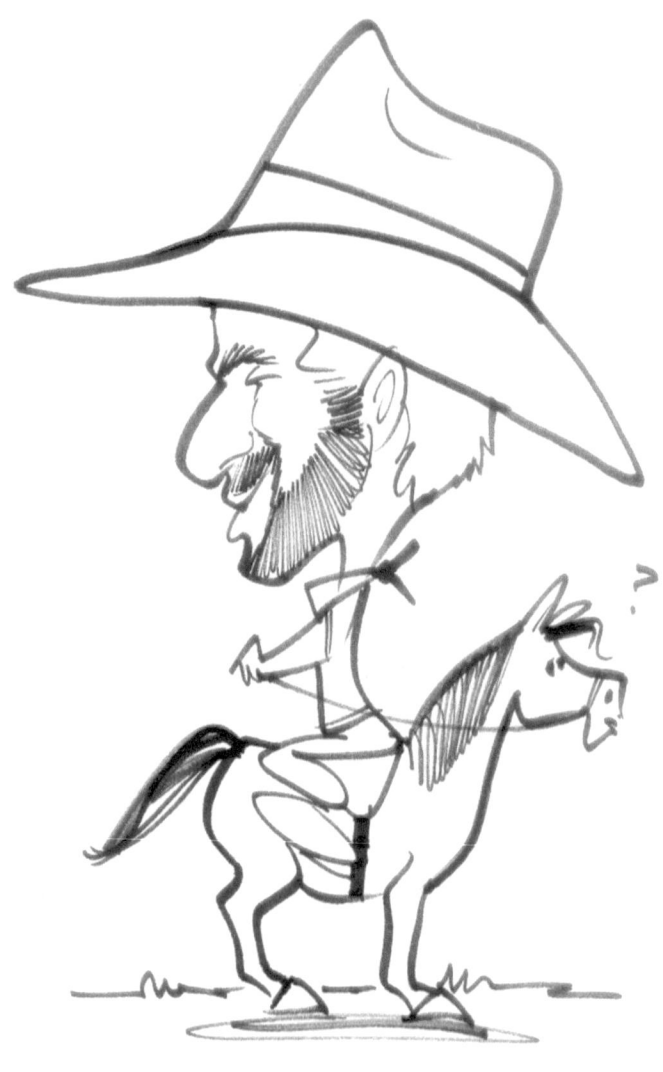

HORSEBACK RIDING 1

HOBBIES

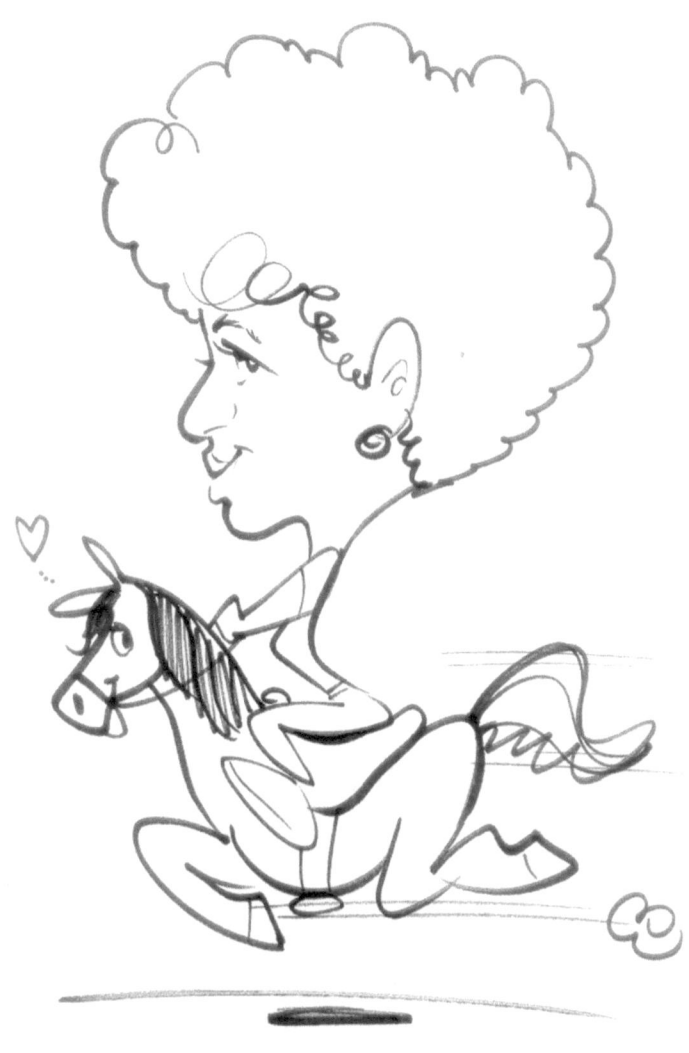

HORSEBACK RIDING II

HOBBIES

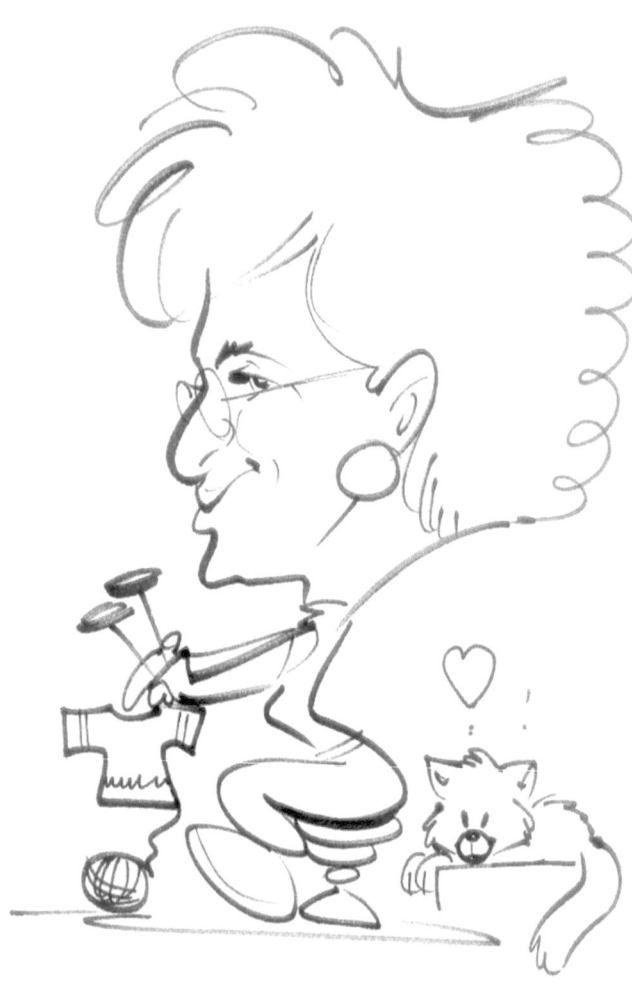

KNITTING

HOBBIES

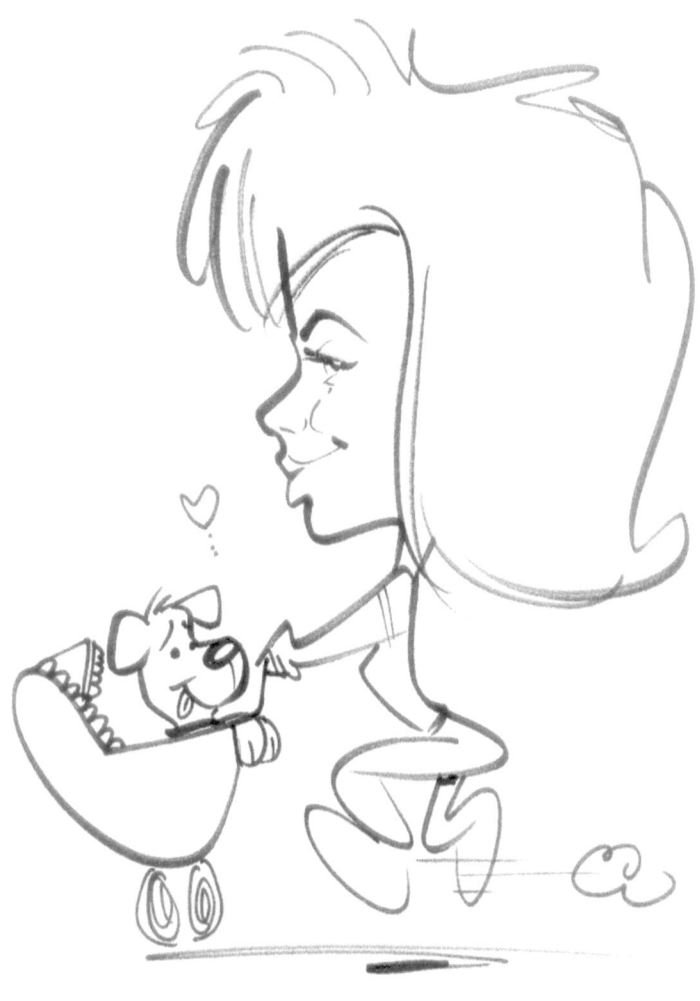

PETS/WALKING THE DOG 1

HOBBIES

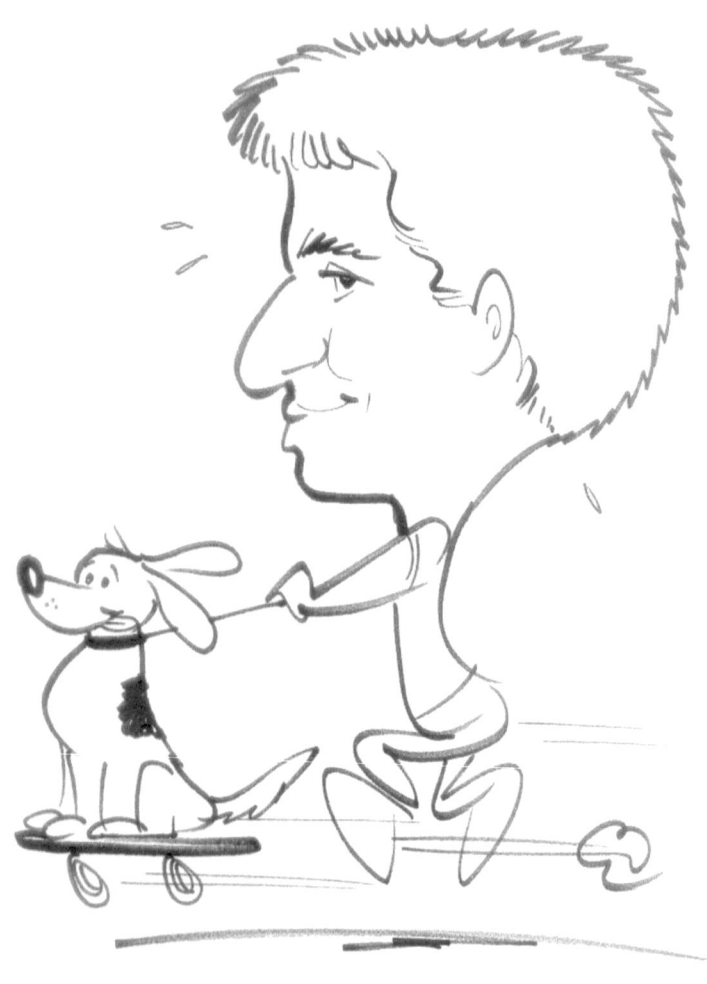

PETS/WALKING THE DOG II

HOBBIES

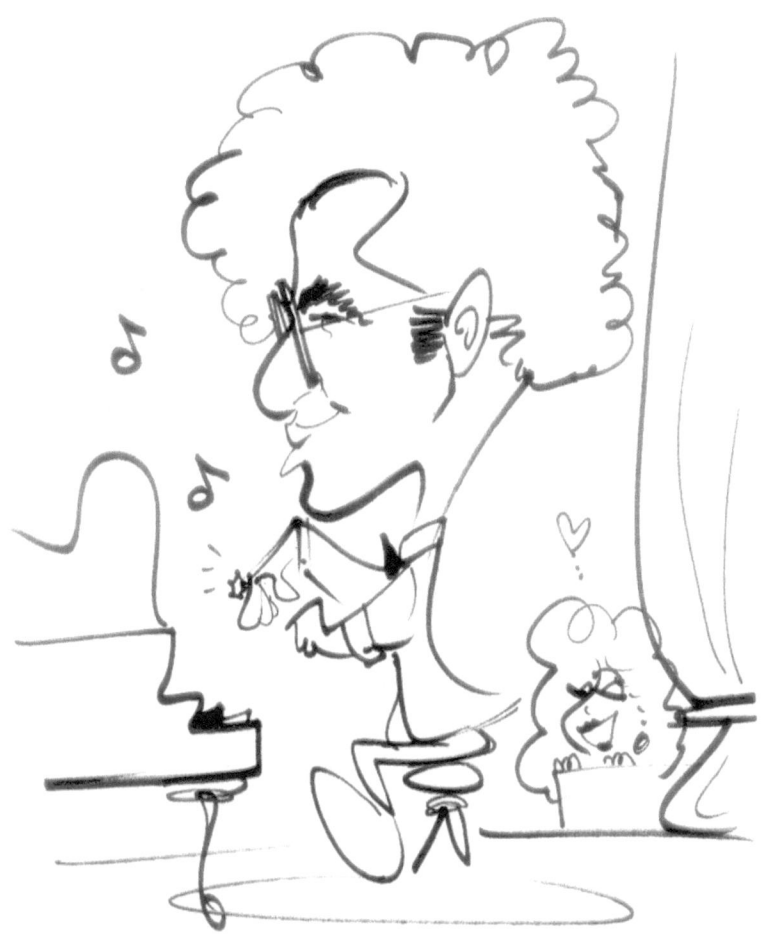

PIANO

HOBBIES

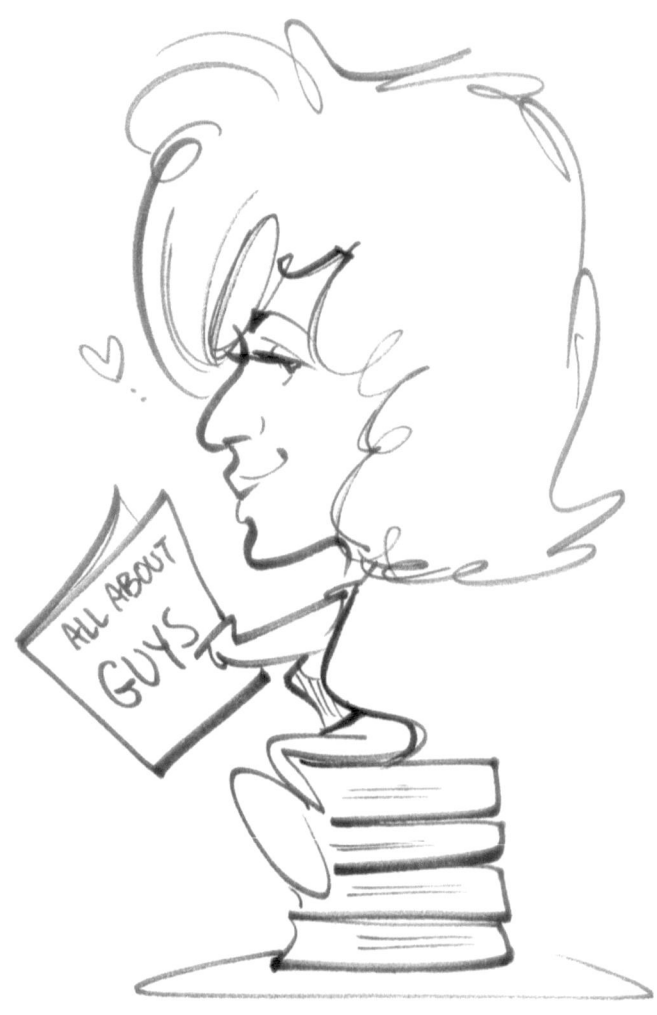

READING

HOBBIES

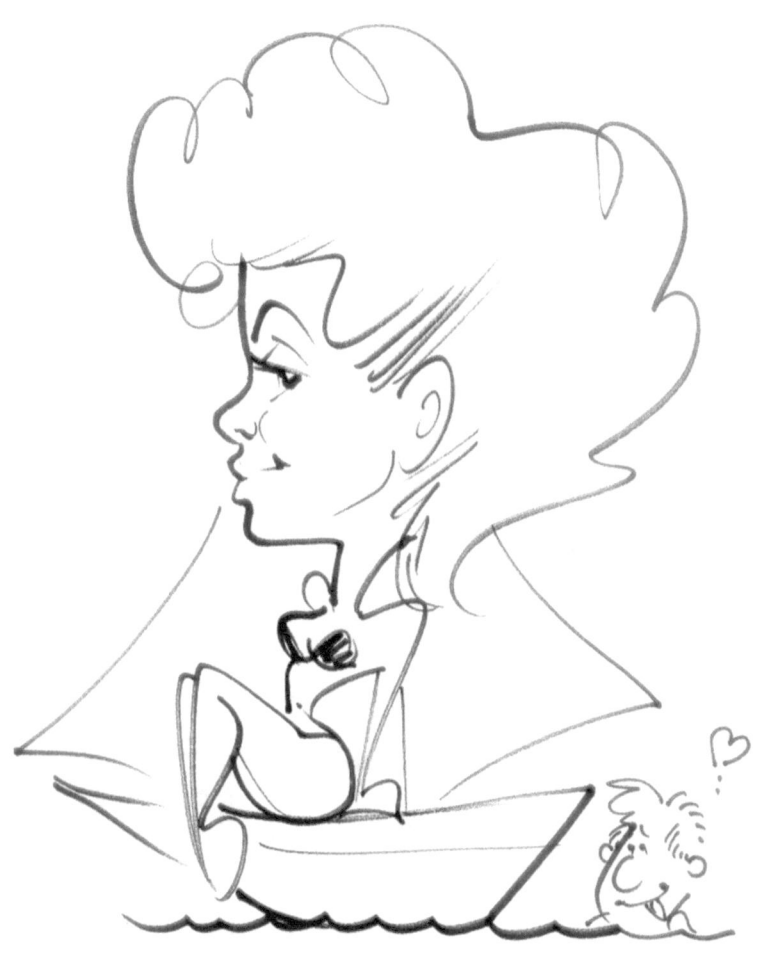

SAILING

HOBBIES

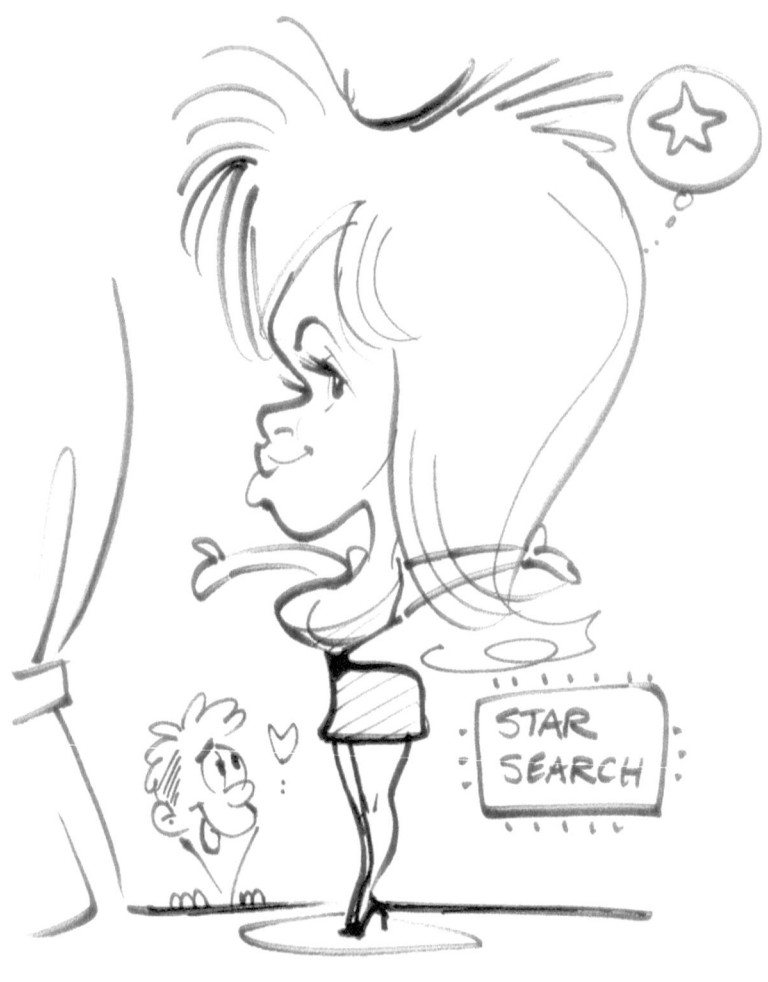

SINGING

HOBBIES

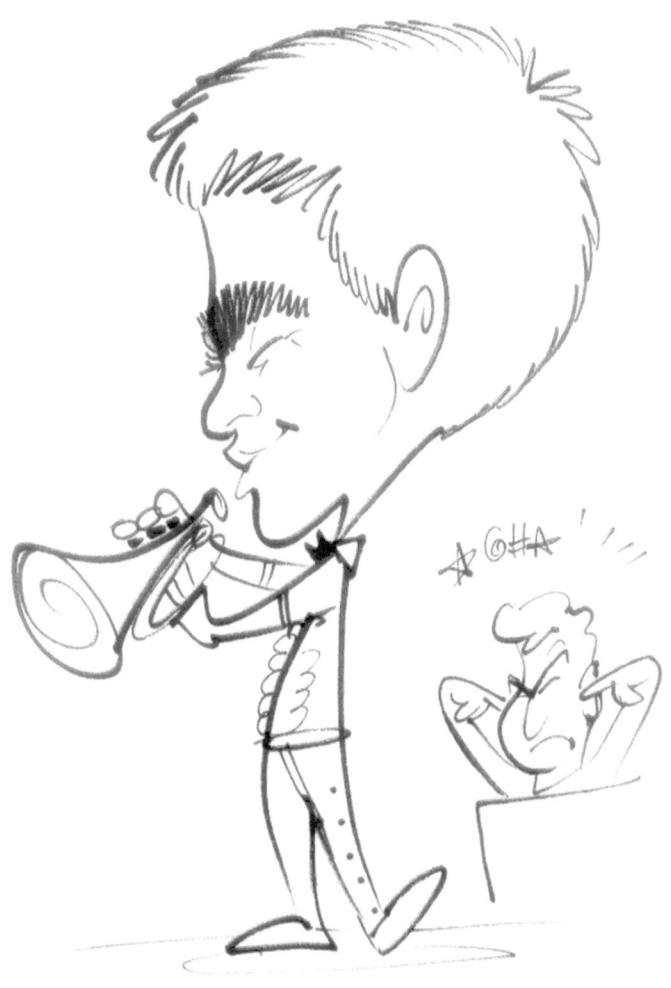

TRUMPET

HOBBIES

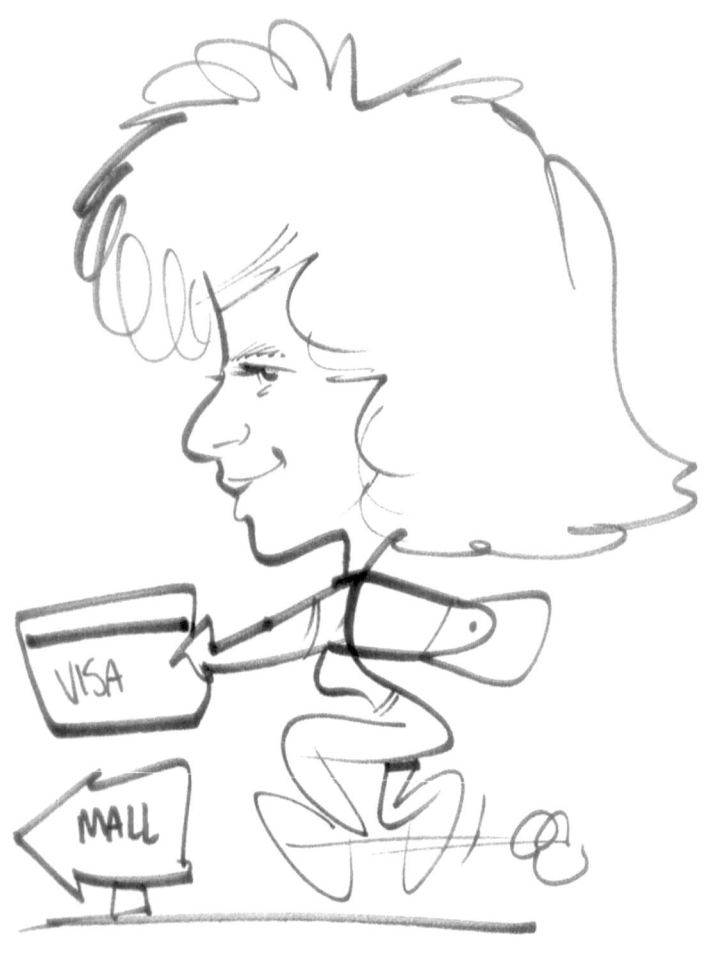

SHOPPING I

HOBBIES

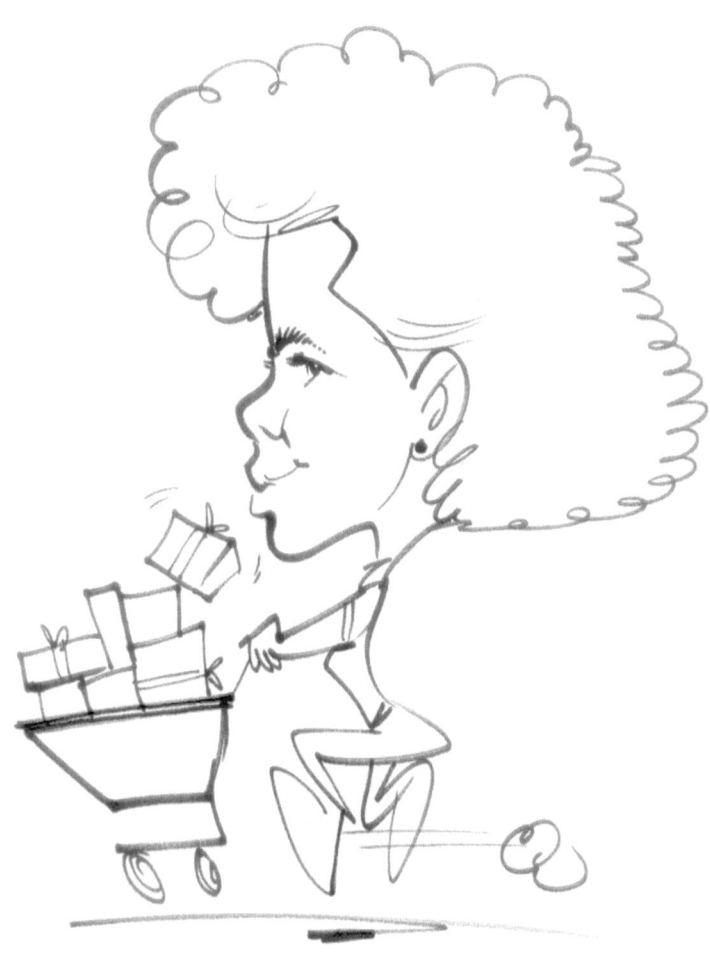

SHOPPING II

HOBBIES

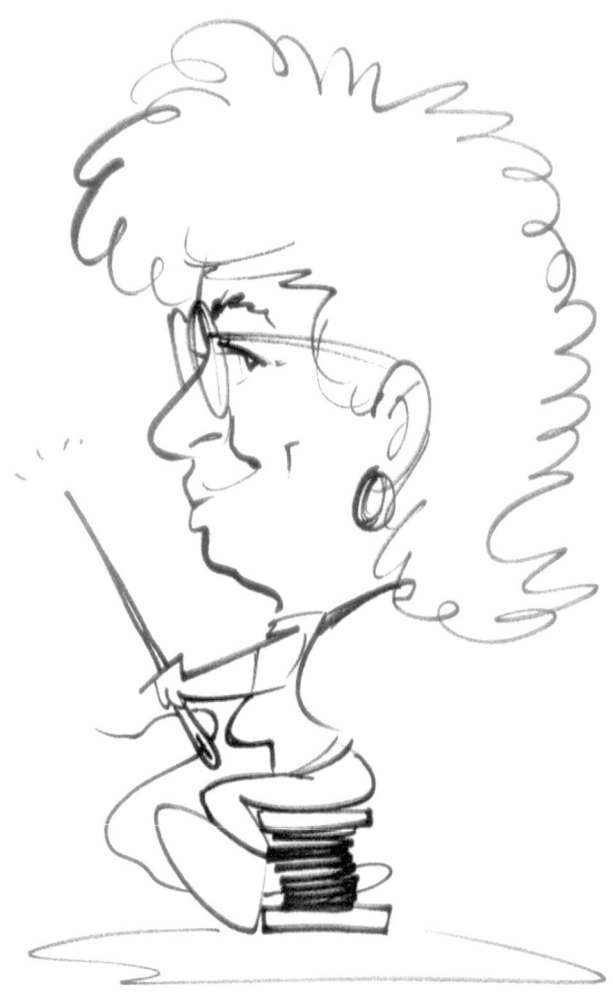

SEWING

PROFESSIONS

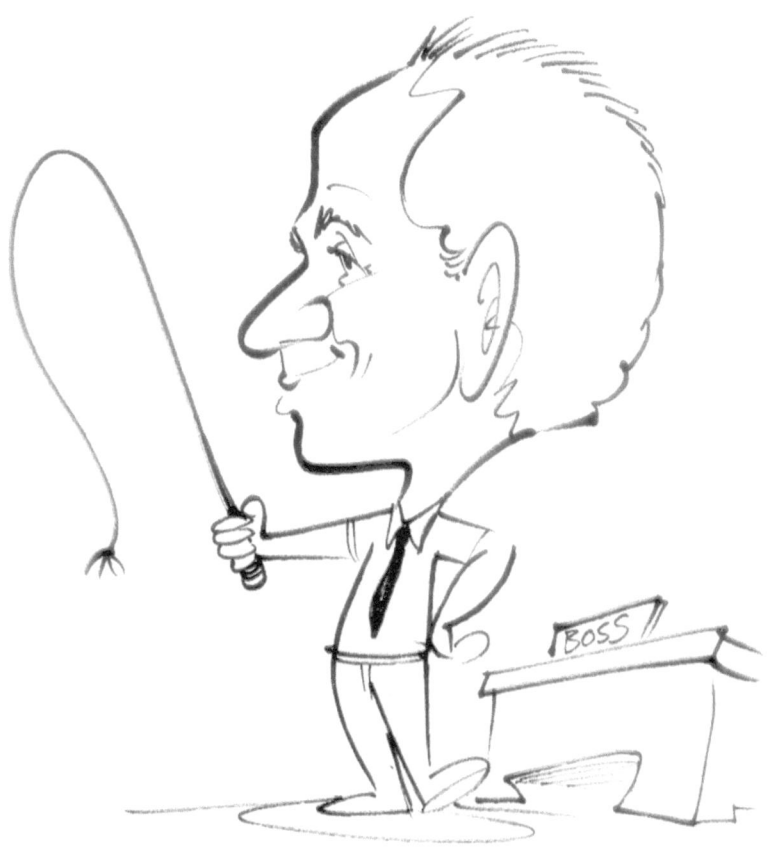

BOSS

PROFESSIONS

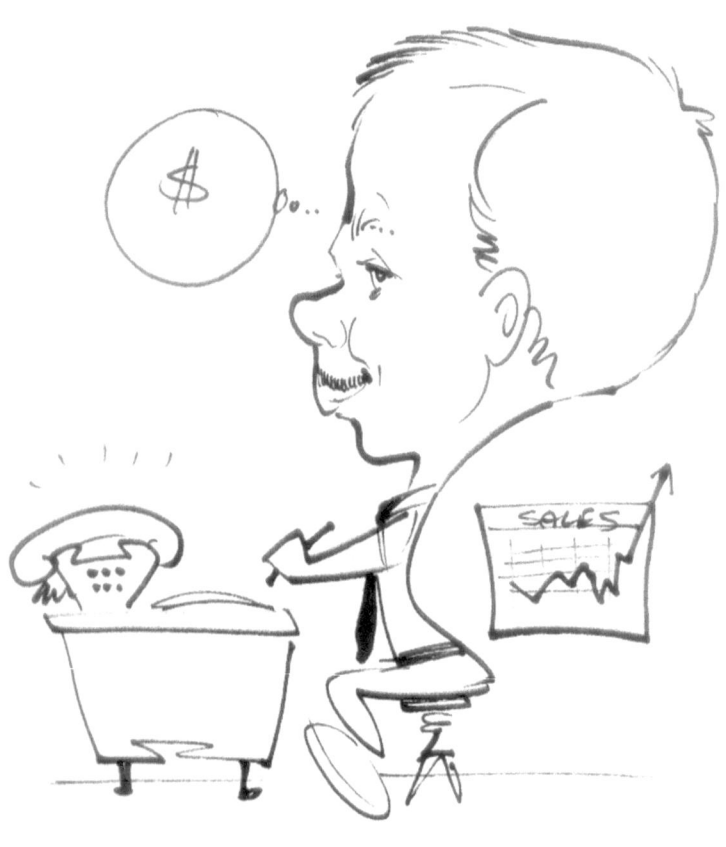

BUSINESSMAN/SALES

PROFESSIONS

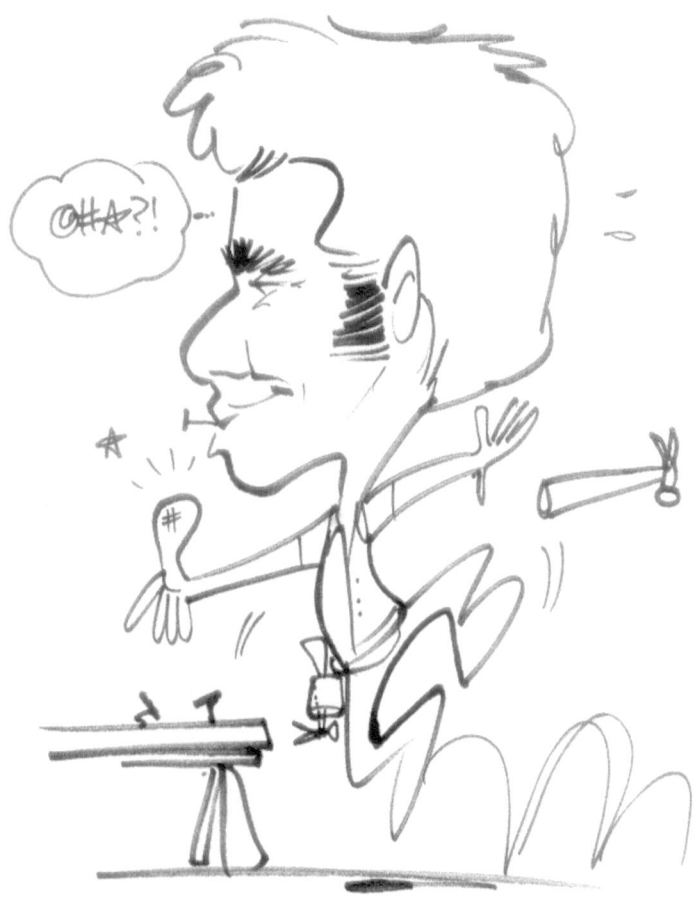

CARPENTER

PROFESSIONS

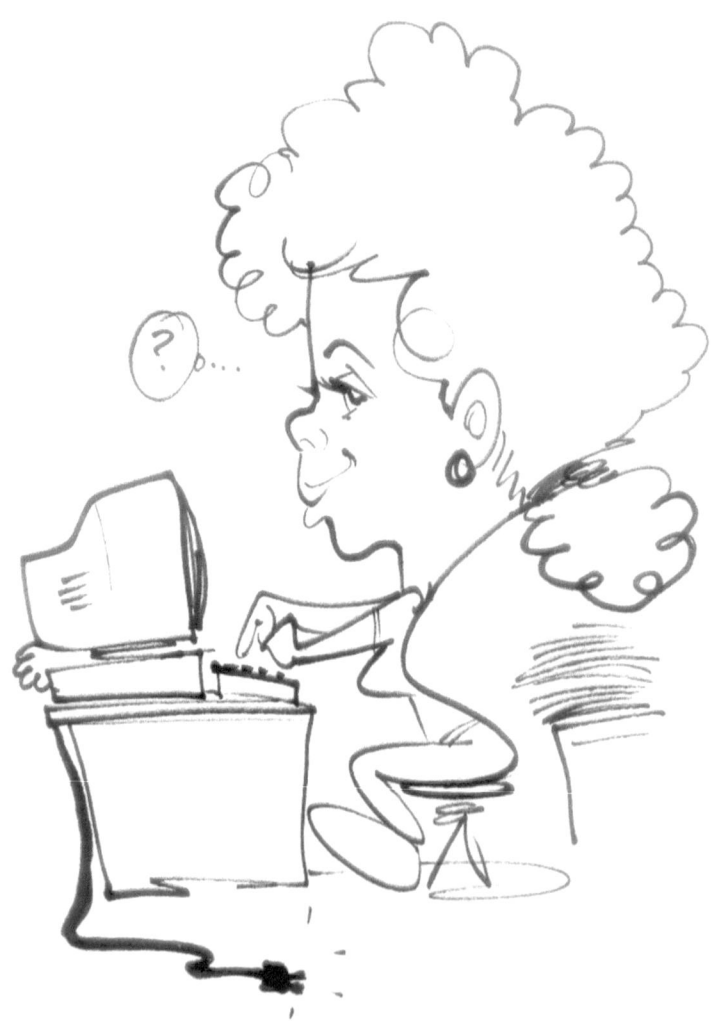

COMPUTER

PROFESSIONS

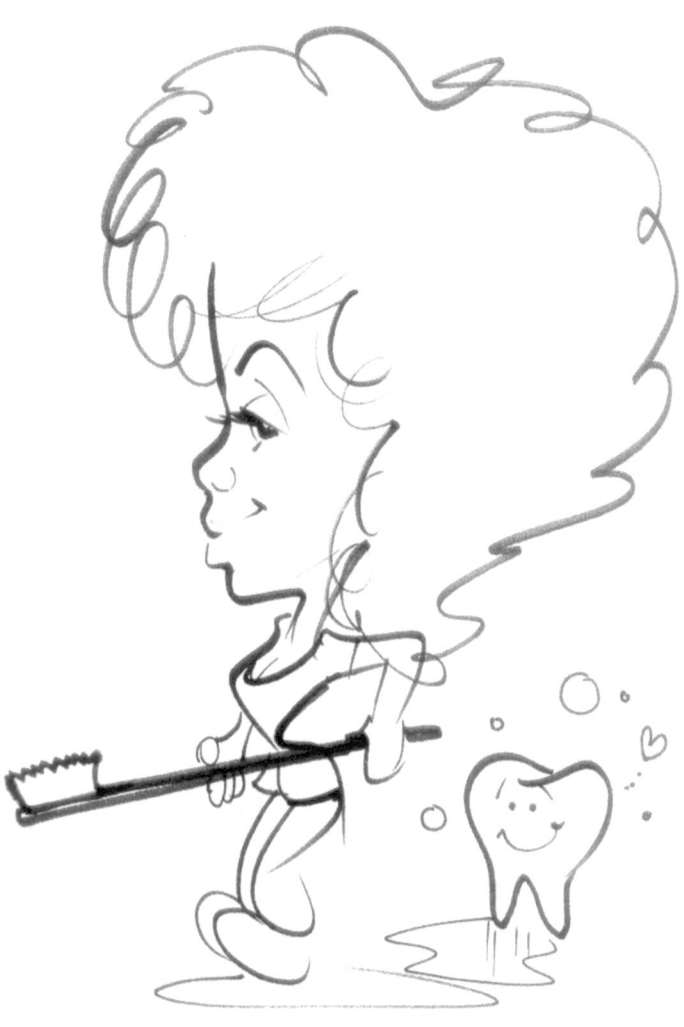

DENTAL HYGIENE

PROFESSIONS

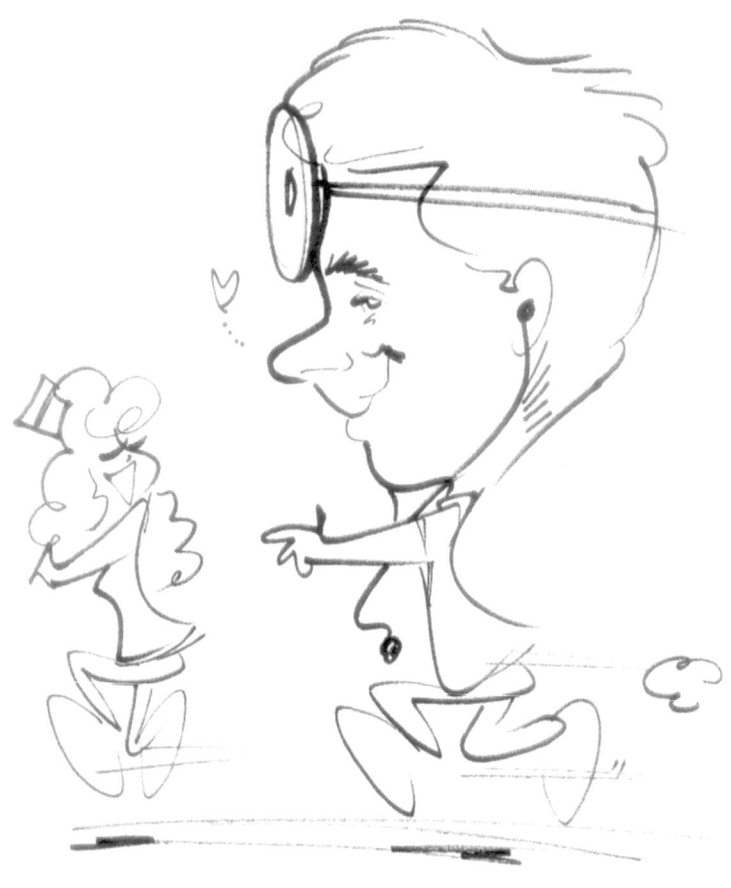

DOCTOR

PROFESSIONS

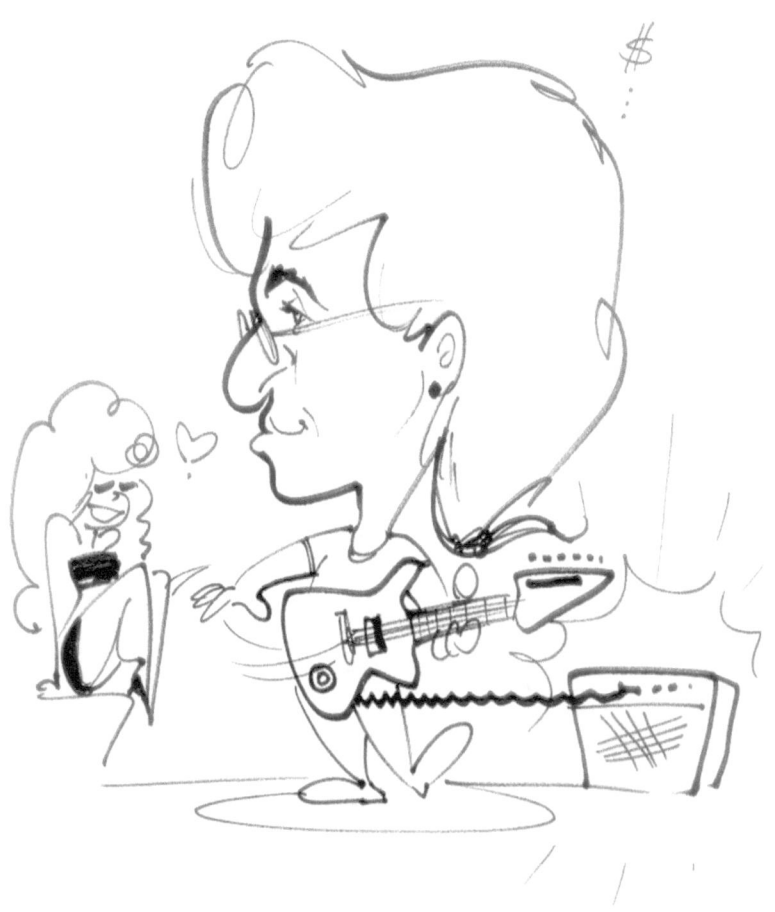

GUITAR

PROFESSIONS

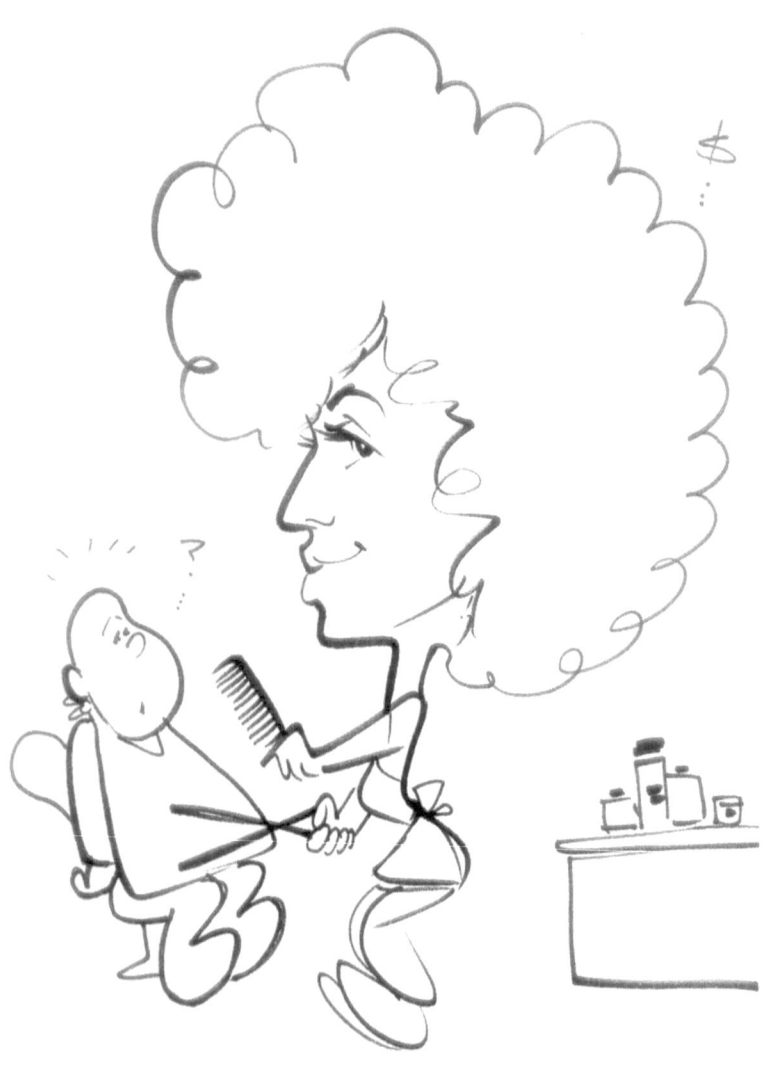

HAIRDRESSER

PROFESSIONS

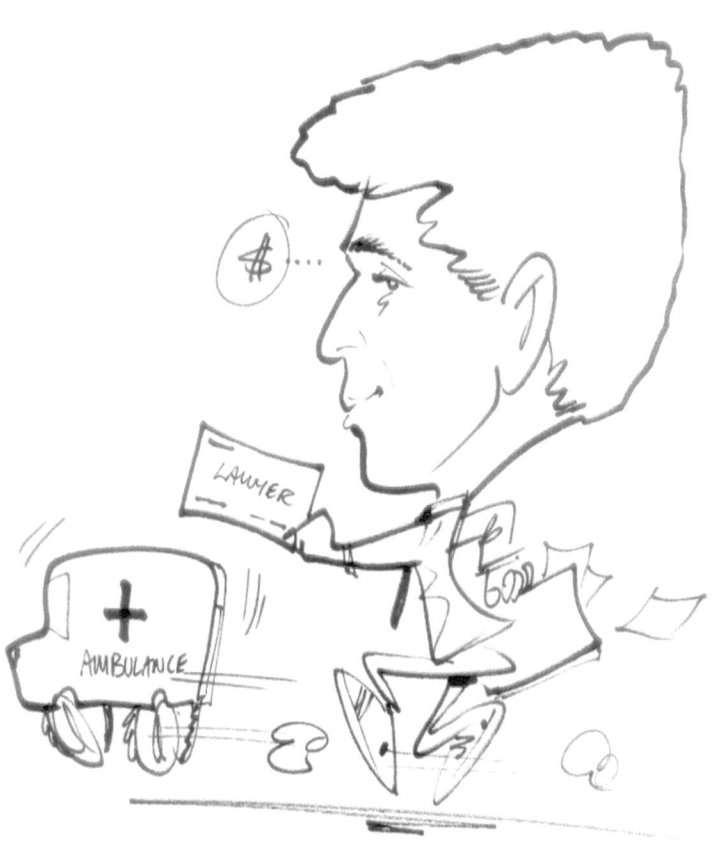

LAWYER

PROFESSIONS

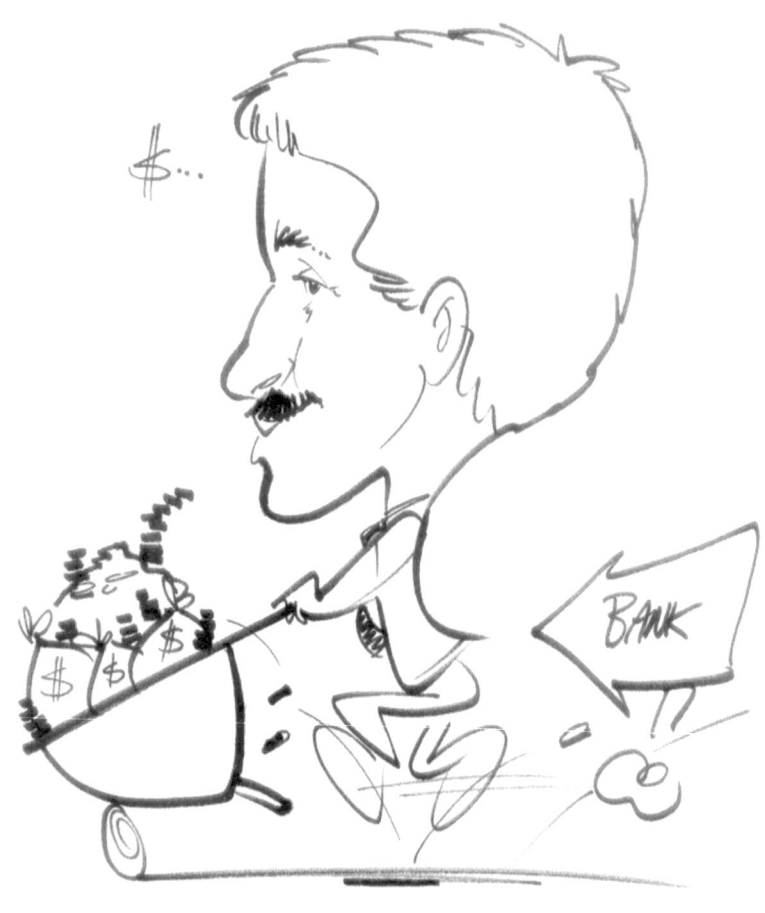

MAKING MONEY

PROFESSIONS

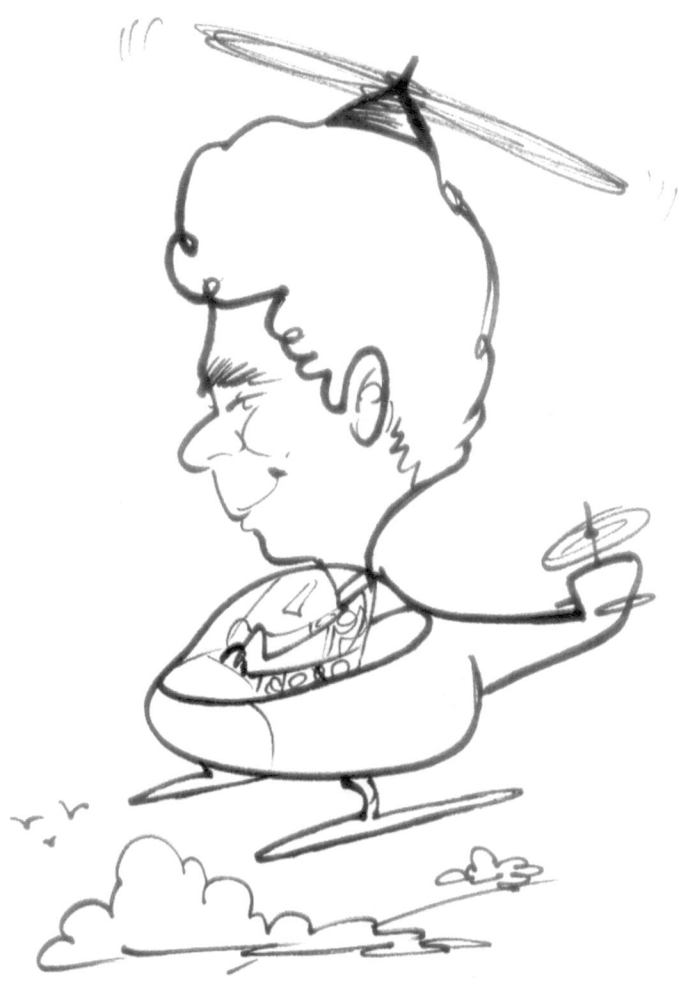

MILITARY/HELICOPTER

PROFESSIONS

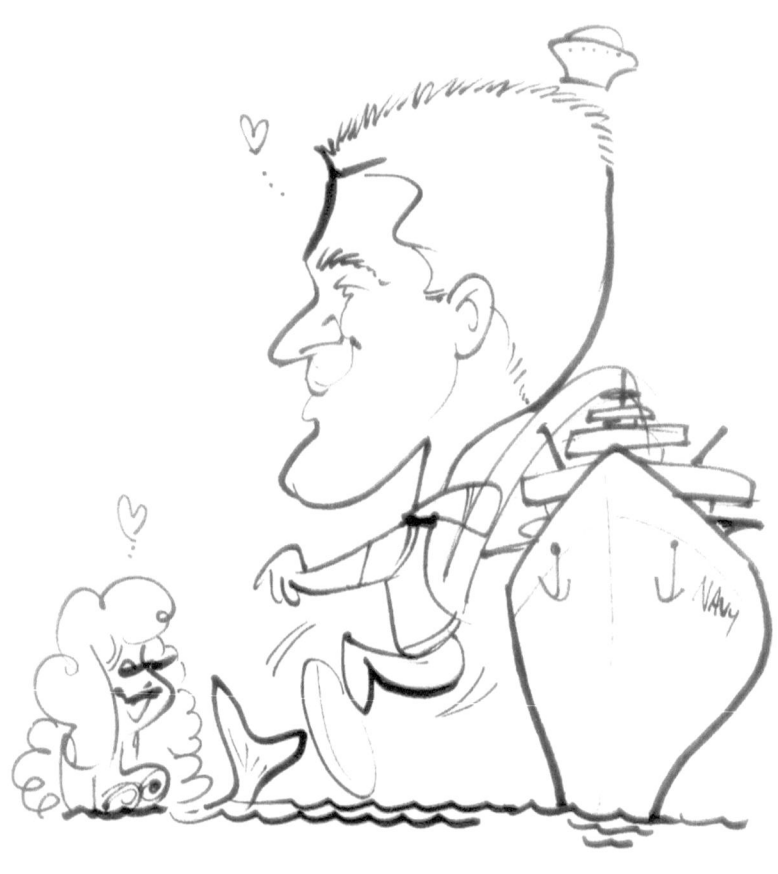

MILITARY/NAVY

PROFESSIONS

MILITARY/PARACHUTE

PROFESSIONS

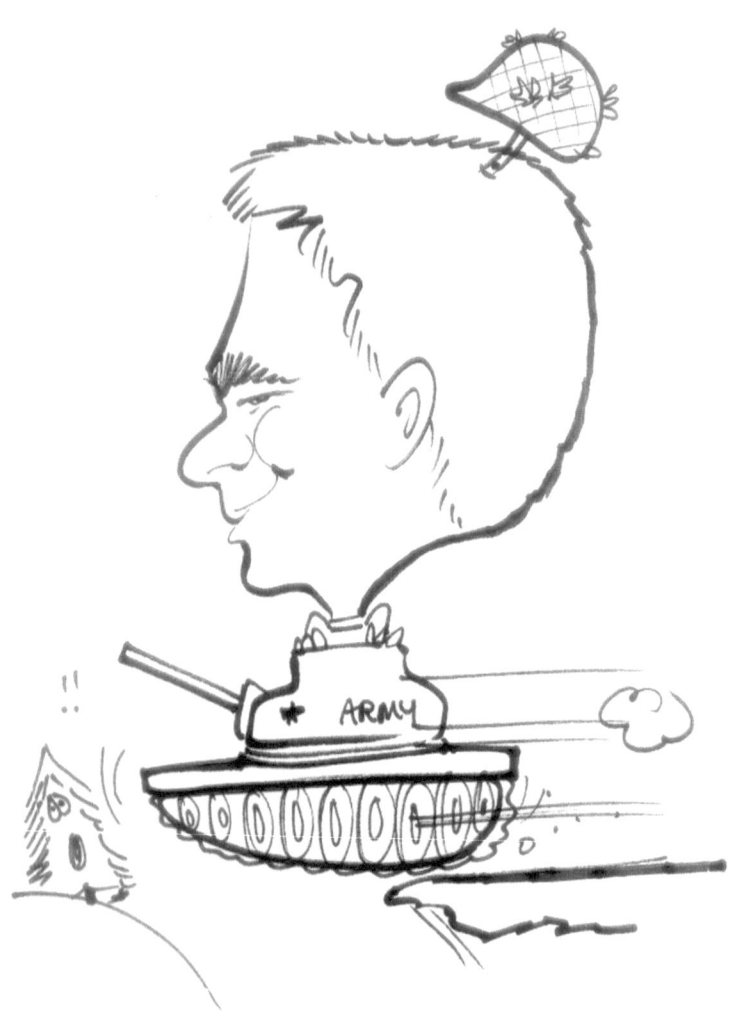

MILITARY/TANK

PROFESSIONS

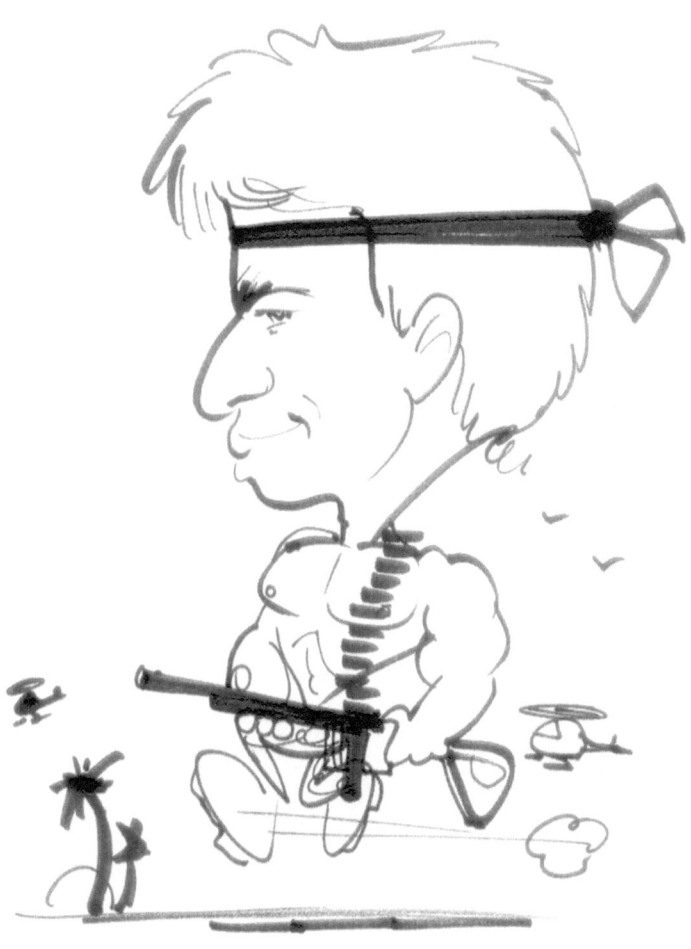

MILITARY/RAMBO

PROFESSIONS

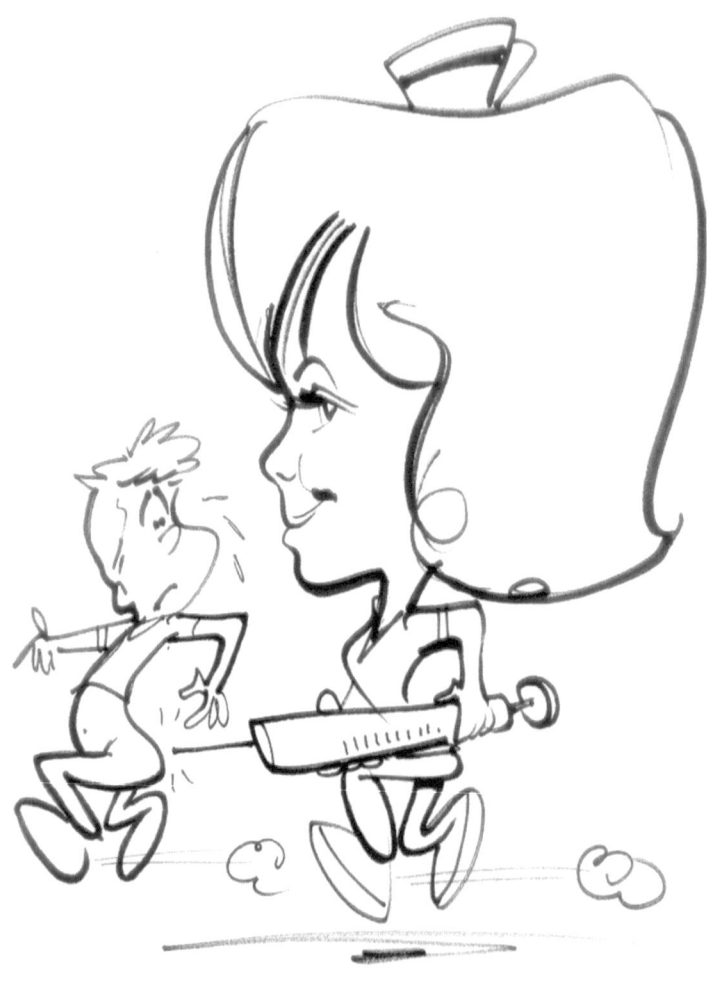

NURSE

PROFESSIONS

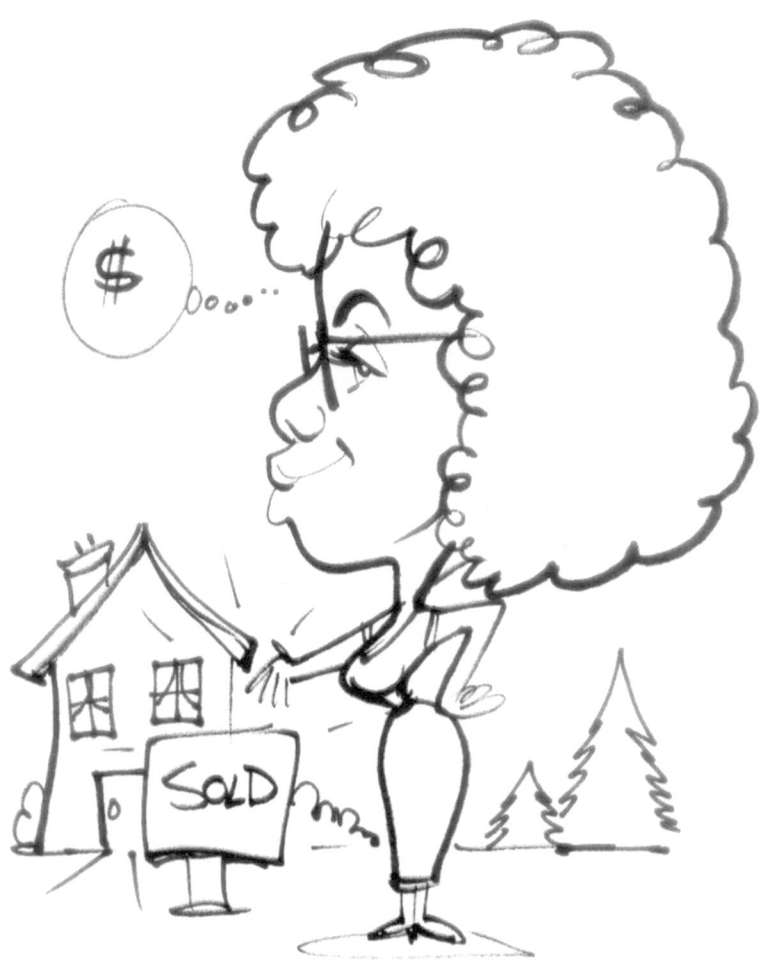

REAL ESTATE

PROFESSIONS

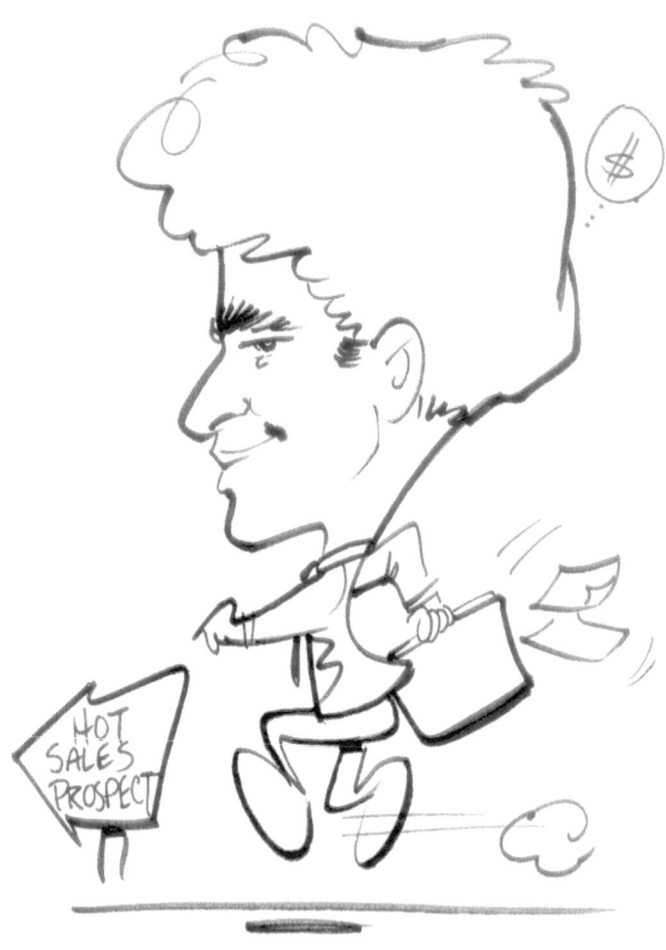

SALESMAN

PROFESSIONS

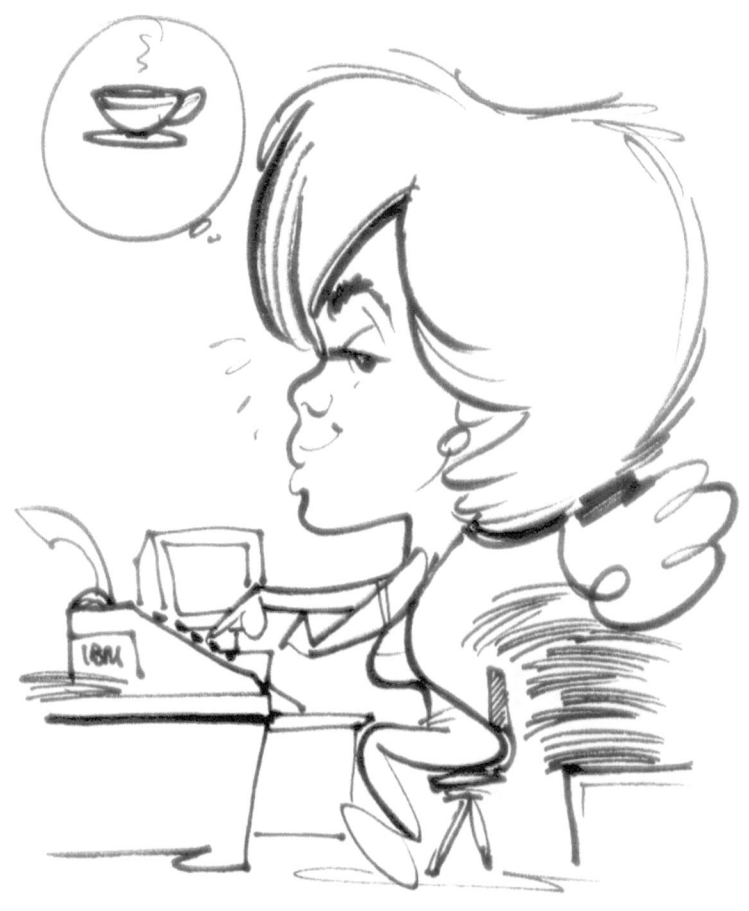

SECRETARY

PROFESSIONS

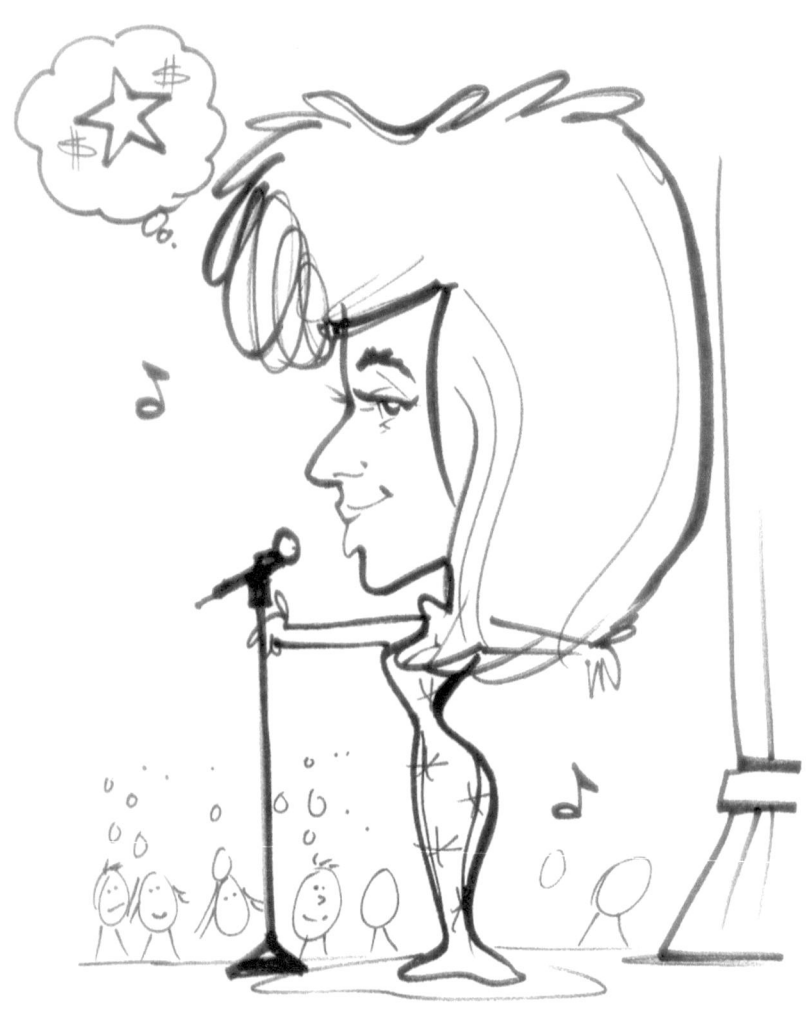

SINGING

PROFESSIONS

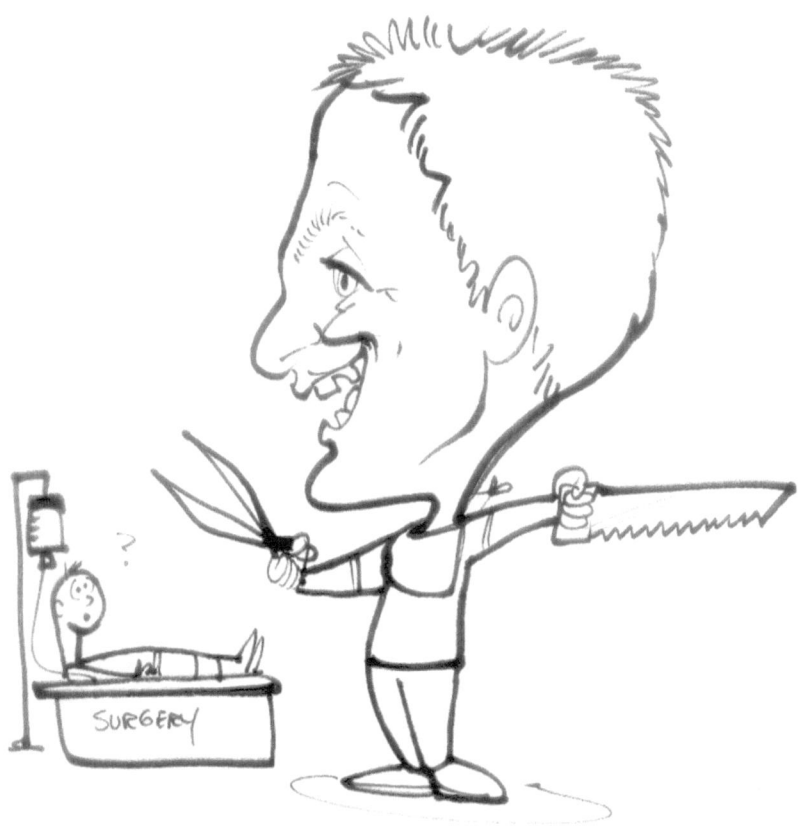

SURGEON

KID'S ONLY

KID'S ONLY

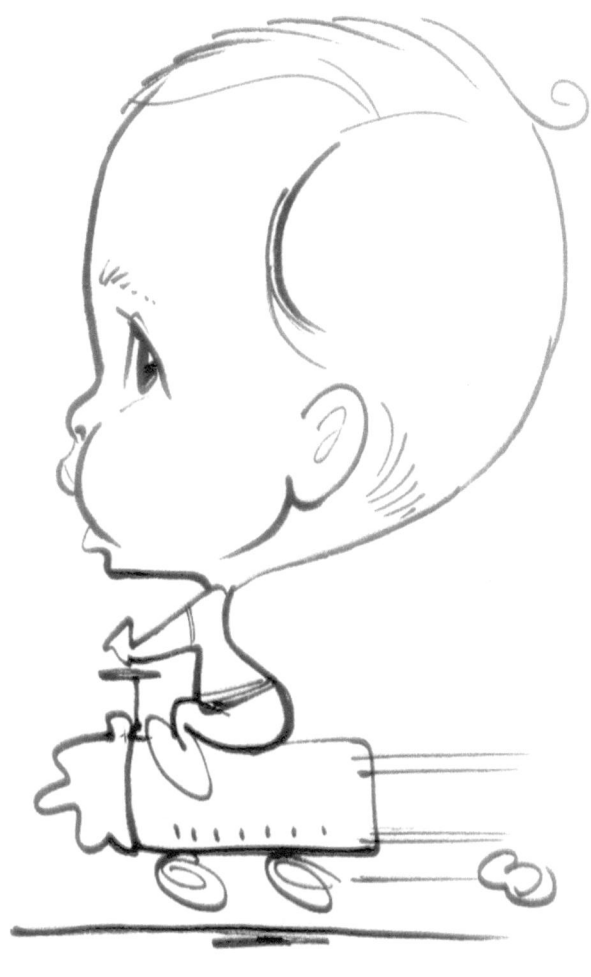

BABIES/BOTTLE

KID'S ONLY

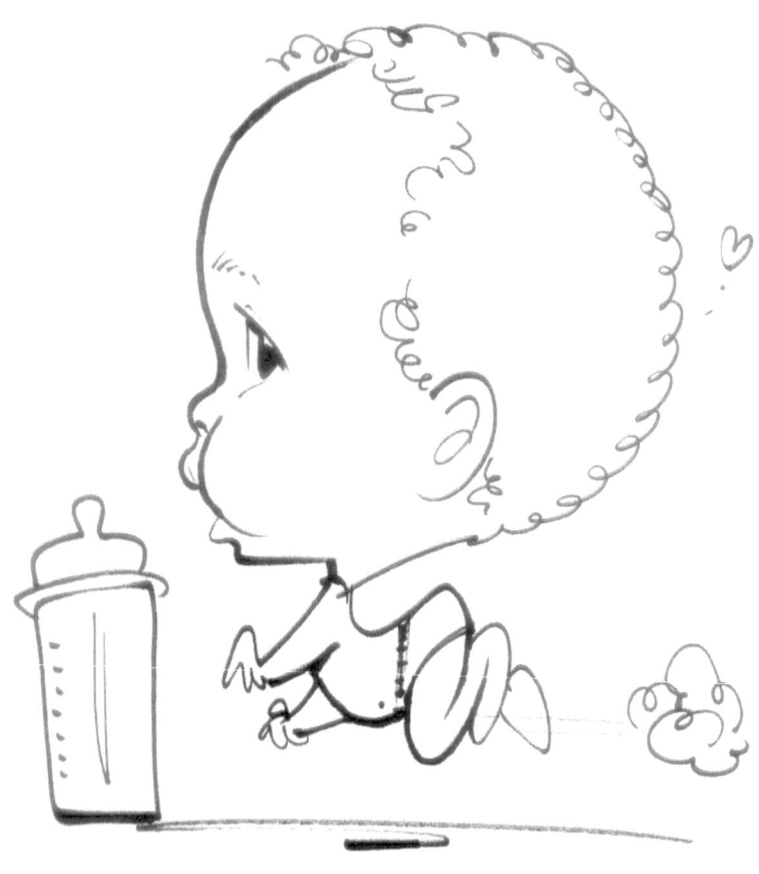

BABIES/CRAWLING

KiD'S ONLY

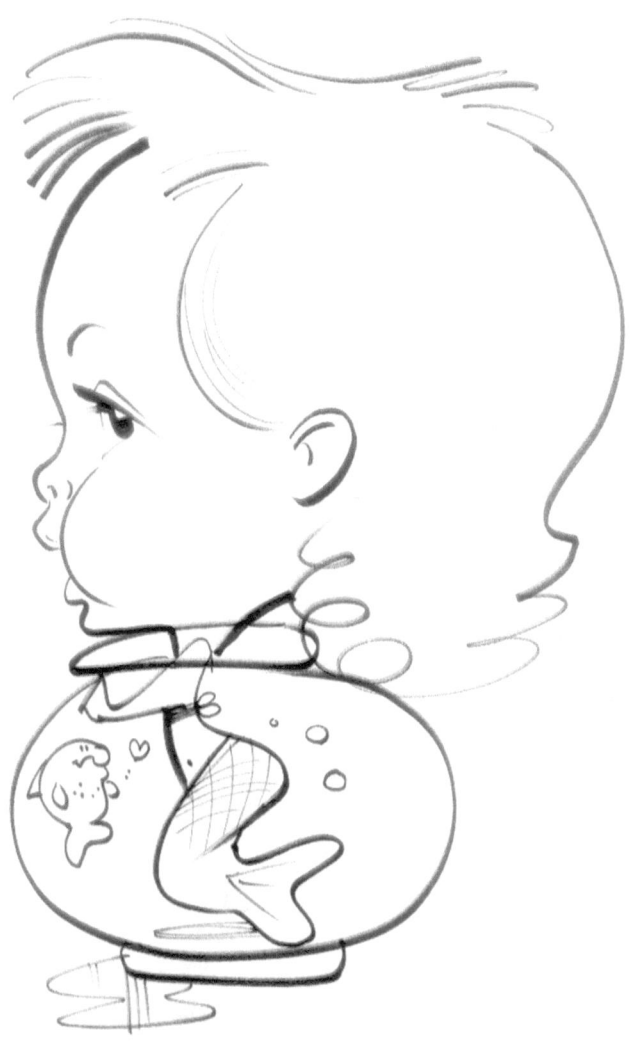

BABIES/SWIMMING/WATER

KID'S ONLY

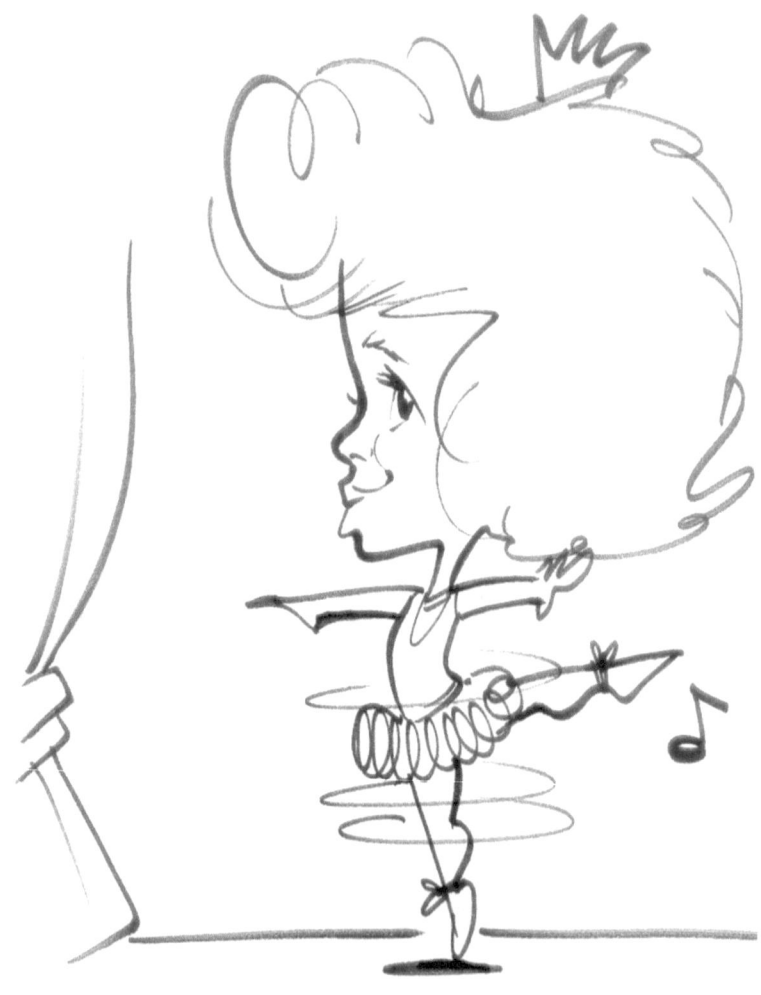

BALLET

KID'S ONLY

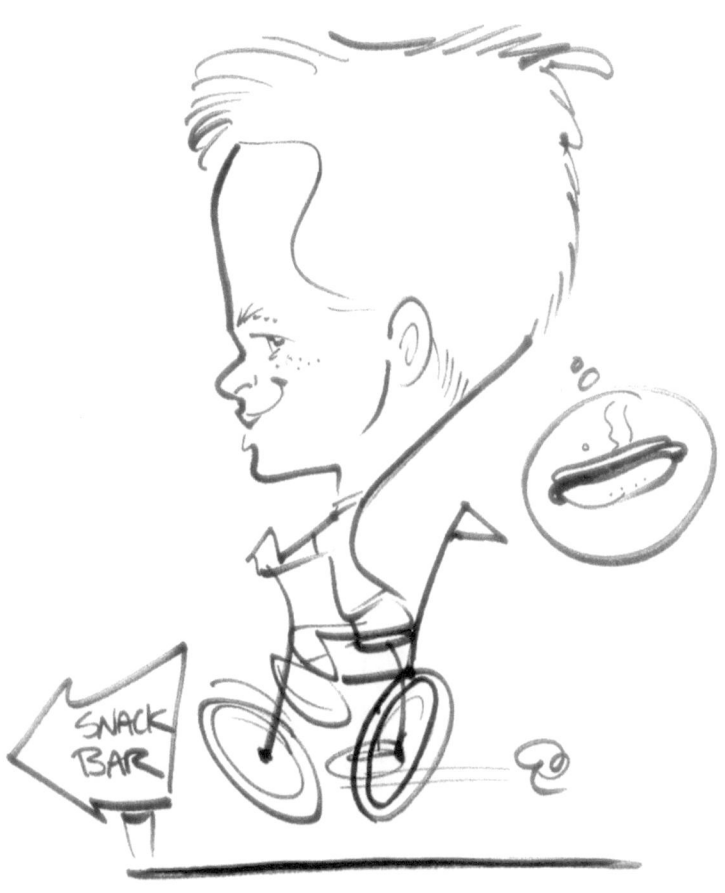

BICYCLE

KID'S ONLY

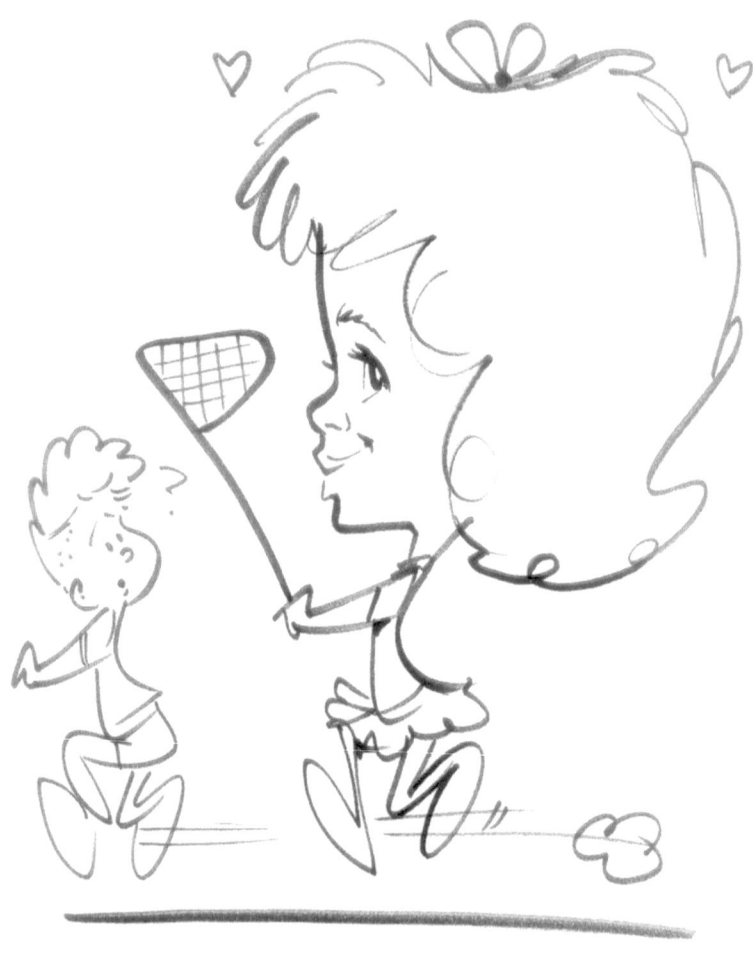

CHASING BOYS

KID'S ONLY

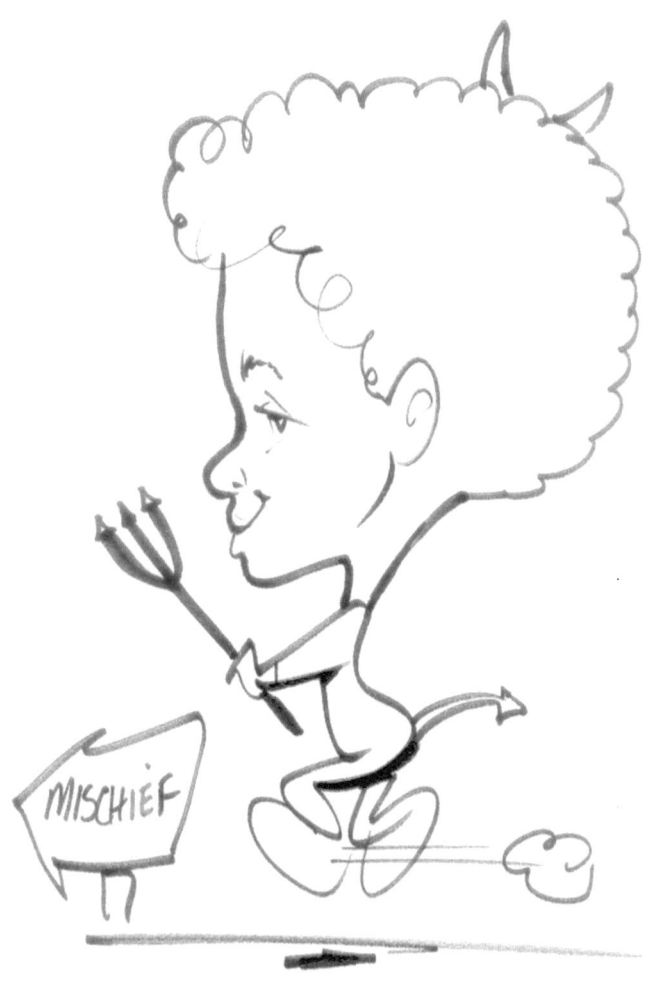

DEVIL

KID'S ONLY

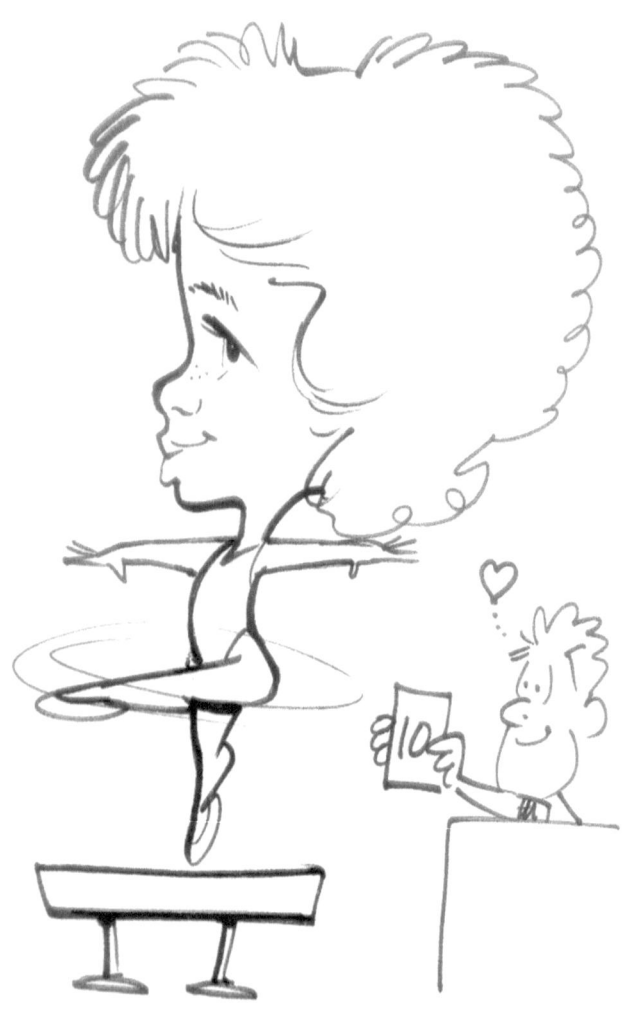

GYMNASTICS

KID'S ONLY

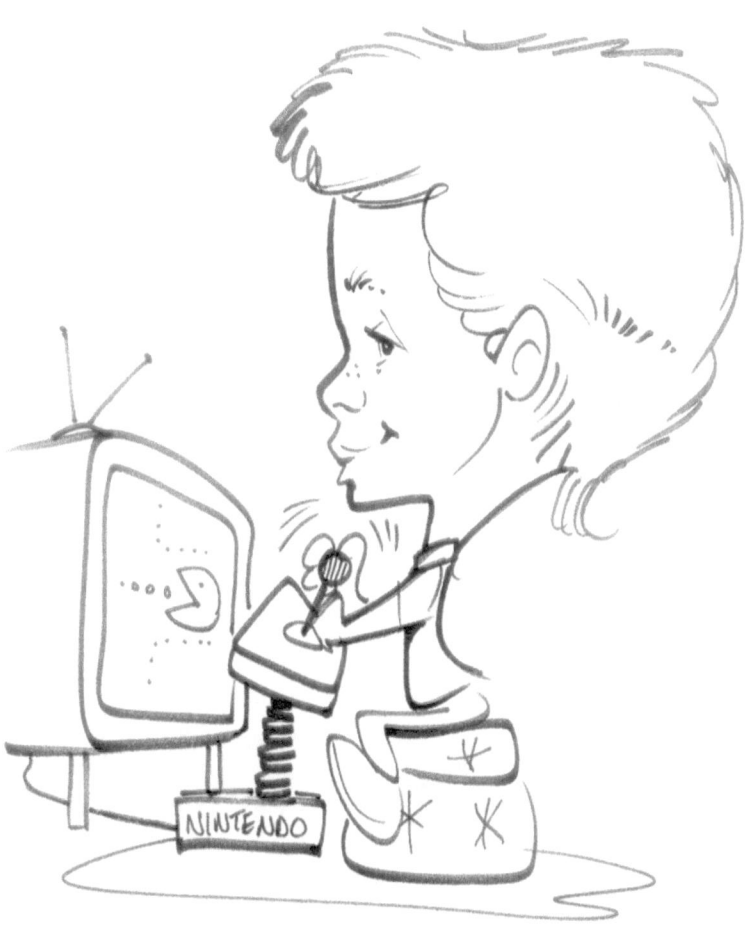

NINTENDO

KID'S ONLY

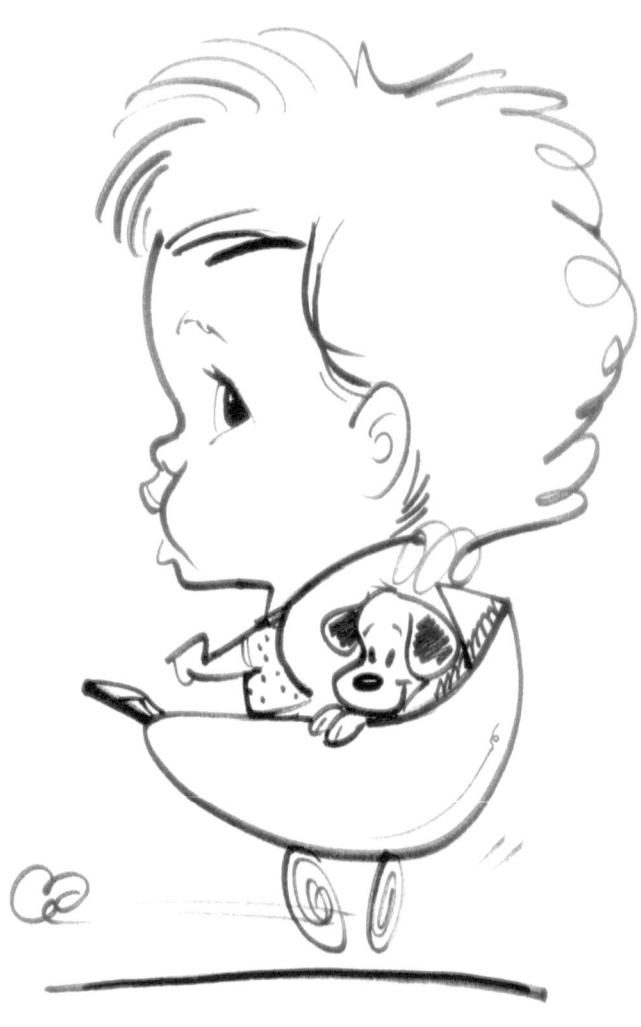

PETS

KID'S ONLY

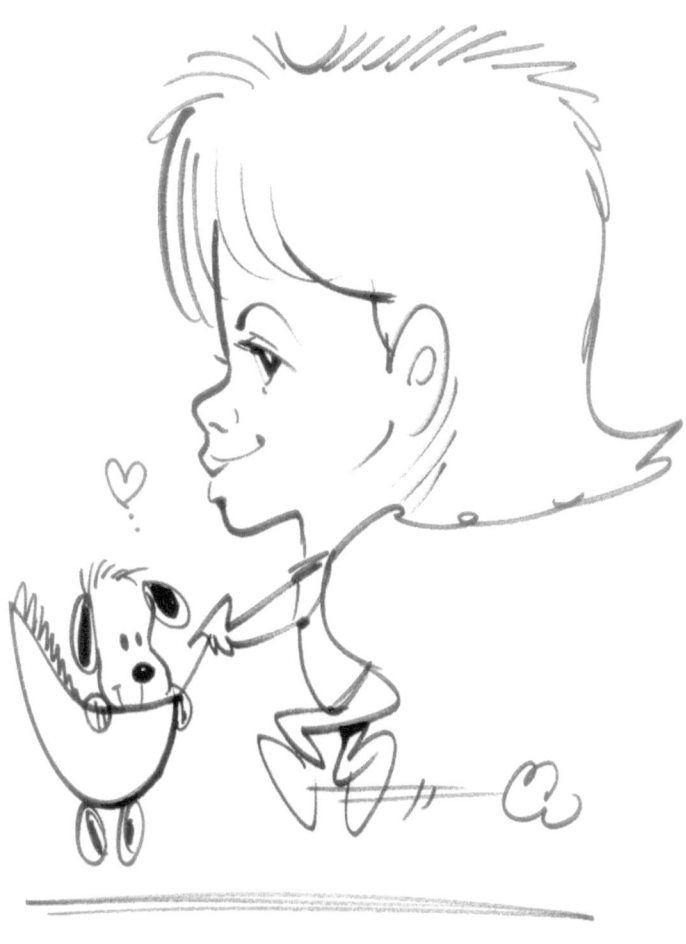

PETS II

KID'S ONLY

ROLLERSKATING

KID'S ONLY

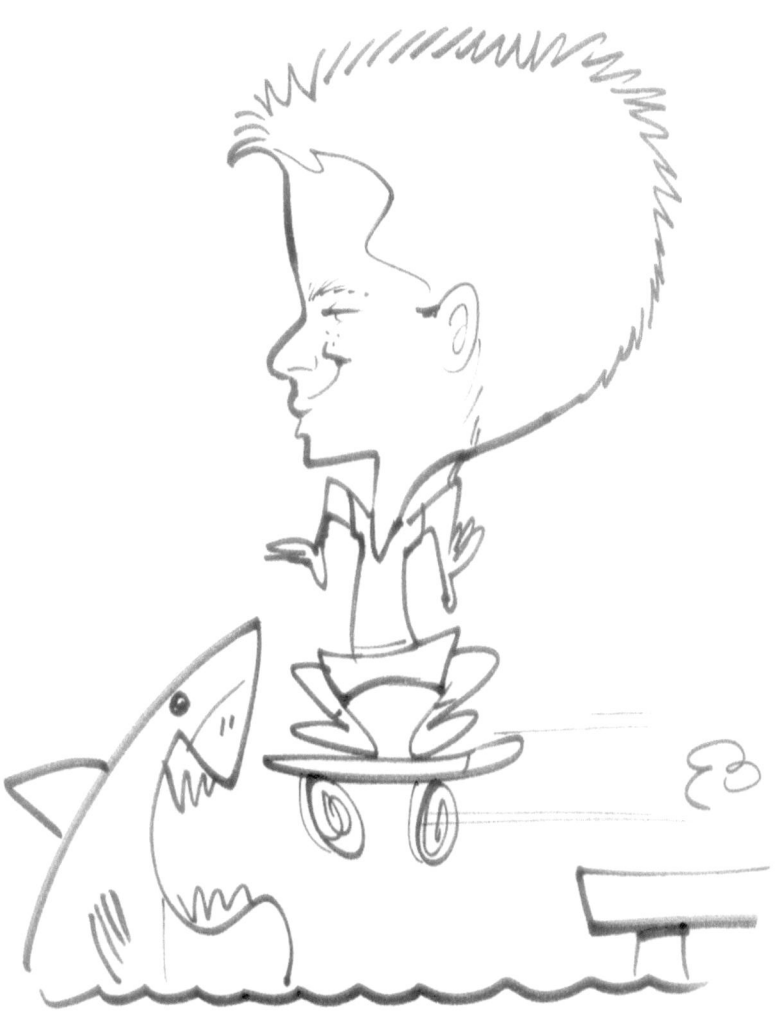

SKATEBOARDING 1

KID'S ONLY

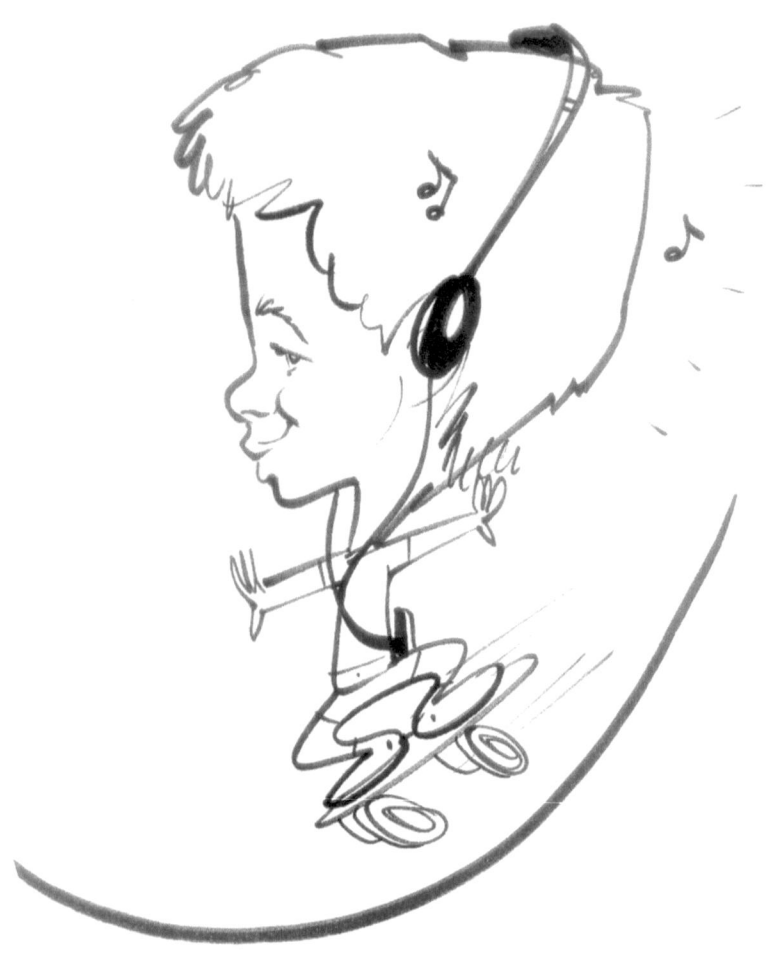

SKATEBOARDING II

KID'S ONLY

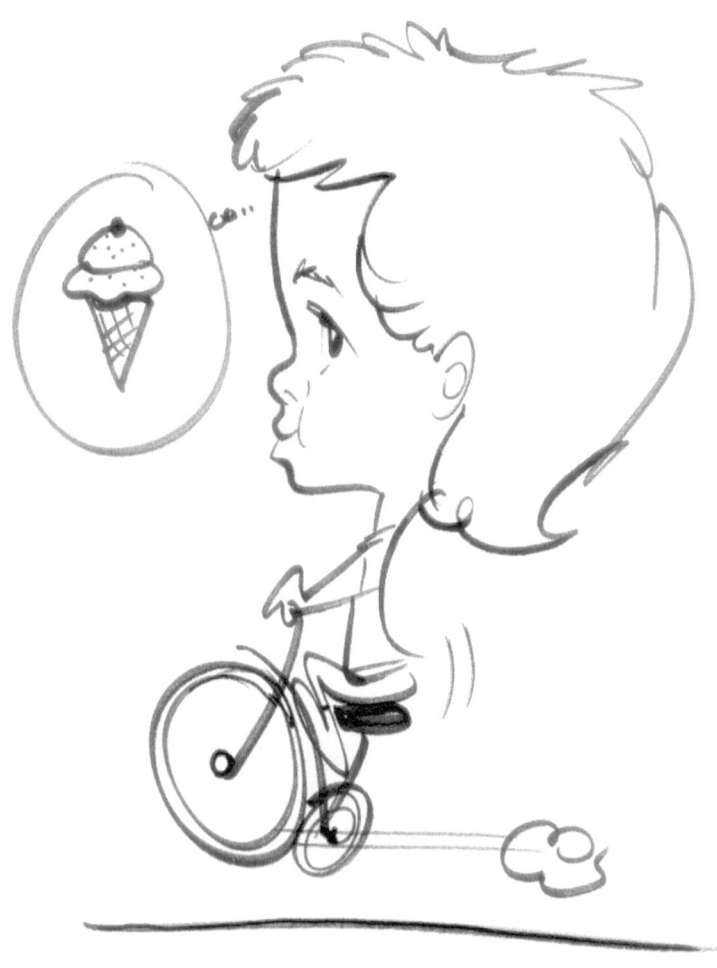

TRICYCLE

KID'S ONLY

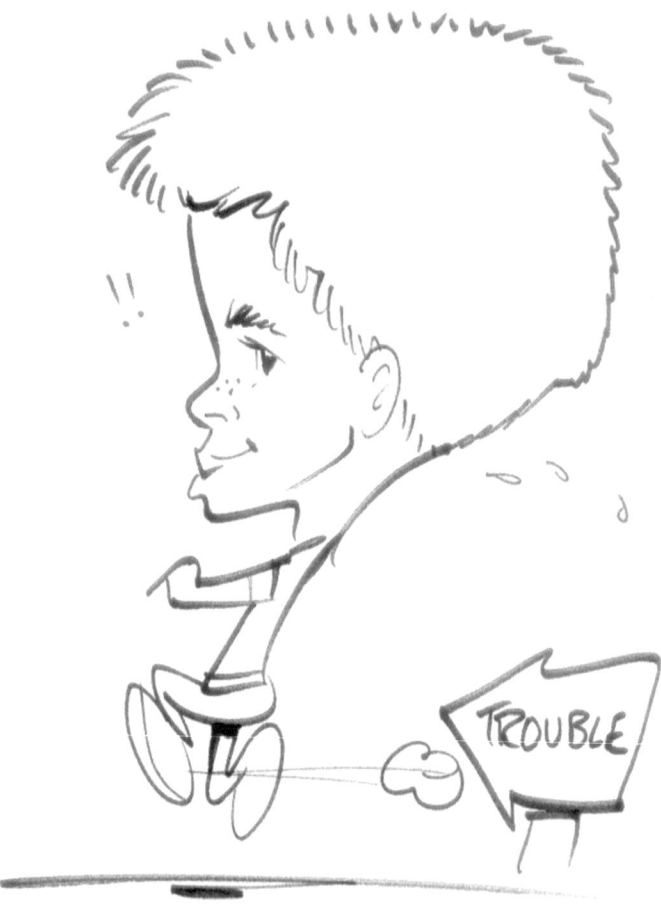

TROUBLE

KID'S ONLY

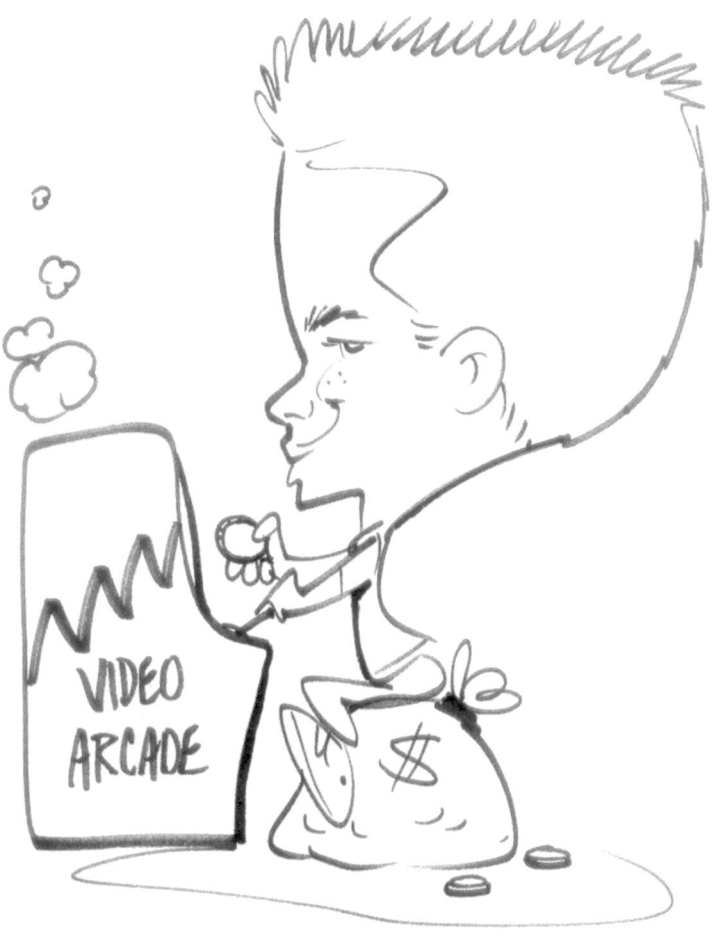

VIDEO ARCADE

www.ingramcontent.com/pod-product-compliance
Lightning Source LLC
Chambersburg PA
CBHW022022170526
45157CB00003B/1322